TODD WEBB

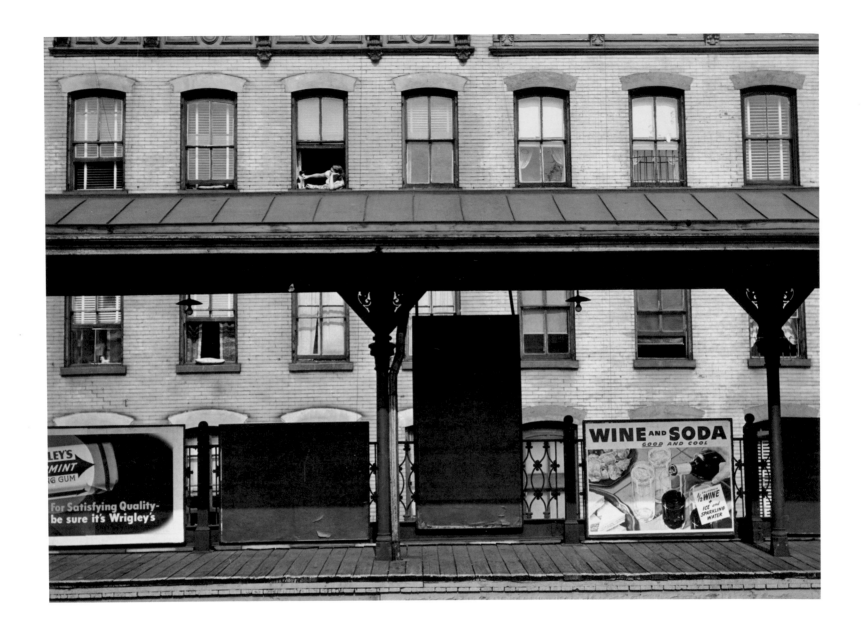

El Station, 53rd Street, New York, 1946

TODD WEBB

Photographs of New York and Paris
1945-1960

by
Keith F. Davis

with
A Reminiscence by Todd Webb

Hallmark Cards, Inc.
Kansas City, Missouri

Acknowledgements

This project has come to fruition through the support and assistance of many people.

It is due to the interest and commitment of Donald J. Hall, Chairman, Hallmark Cards, Inc., that the Hallmark Photographic Collection was begun over two decades ago and that it has played an innovative role in the history of corporate support of photography.

The Center for Creative Photography, at the University of Arizona in Tucson, provided invaluable research assistance, and thanks go to Terence Pitts, Amy Stark, and Stuart Alexander. The Photographic Archives at the University of Louisville, Kentucky, made their extensive Roy Stryker/Standard Oil archives available for research, and appreciation goes to James C. Anderson and David Horvath for their help. Thanks to Peter Galassi and Sarah Anne McNear of the Museum of Modern Art, New York, for data on their holdings. The Museum of the City of New York provided helpful information in the early stages of this project.

For related advice and assistance, thanks go to Beaumont Newhall, Thomas Southall and Edwynn Houk.

Thanks, also, to Joy Wightman for her sensitive design of the catalog, and to Frank Blair and Charlie Waggener of Hallmark's Graphic Arts Division for overseeing its production.

Deepest thanks go to Todd and Lucille Webb for their friendship, kindness and assistance in making this project possible.

This book was published on the occasion of the traveling exhibition *Todd Webb: Photographs of New York and Paris, 1945-1960*, organized by, and from the holdings of, The Hallmark Photographic Collection. This Collection is a project of the Public Affairs and Communications Division of Hallmark Cards, Inc., Kansas City, Missouri, and reflects a larger company philosophy of support of the fine arts and community service.

© 1986 Hallmark Cards, Inc. Kansas City, Missouri

Distributed by the University of New Mexico Press, Albuquerque, New Mexico

Designed by Joy Wightman
Printed in 200-line duotone, in an edition of 5000 copies.

ISBN: 0-87529-620-3

Cover: Detail in Pavement in Front of the Institut de France, Paris, 1949

INTRODUCTION

This survey of Todd Webb's work seems a particularly appropriate undertaking for the Hallmark Photographic Collection. Begun in 1964, the HPC now includes over 1400 prints by nearly 140 leading 20th century photographers. The goal of the HPC as a whole has been to both represent important aspects of the artistic history of photography in this century, and to create exhibits which present that history in stimulating and original ways. Exhibits assembled from this holding are toured to leading city and university art museums across the country and, on occasion, overseas. In recent years, these exhibitions have included *Lewis Hine: Human Documents, Harry Callahan: Photographs, Edward Weston: One Hundred Photographs from the Nelson-Atkins Museum of Art and the Hallmark Photographic Collection, Andre Kertesz: Form and Feeling, Berenice Abbott and Imogen Cunningham, The Lay of the Land: 20th Century Landscape Photographs, Cityscapes: 20th Century Urban Images,* and *Faces.*

The earliest of these exhibitions, a 141-print Harry Callahan show, was first presented in 1964, at the Hallmark Gallery at 720 Fifth Avenue in New York City. The Hallmark Photographic Collection grew around this timely original purchase with the subsequent addition of bodies of work by Edward Steichen, Imogen Cunningham, Edward Weston, Robert Capa, Andre Kertesz, Henri Cartier-Bresson and many others. Given the primacy of the Callahan holding, the HPC as a whole has paid particular attention to those artists associated with him in important ways. These include aesthetic influences such as Laszlo Moholy-Nagy, peers and associates such as Arthur Siegel, Todd Webb and Aaron Siskind, and former students such as Art Sinsabaugh, Ray Metzker, Ken Josephson, Charles Swedlund, Emmet Gowin and Linda Connor.

Todd Webb's work was first added to the Hallmark Photographic Collection in 1982. The five prints purchased at that time were relatively small in size — 5x7" and 8x10" contact prints — and quiet in mood. And yet they had a power and integrity that stemmed, it seems in hindsight, from their utter honesty of purpose and unabashed love of place. These gentle, carefully seen images from the 1940s and '50s were unexpectedly memorable and remarkably fresh. Webb's name had been familiar due to his associa-tion with his friend Harry Callahan, but relatively few published references were immediately available. However, the quality of these images prompted further research, correspondence, and, shortly later, a visit to his home in Maine.

When the full dimension of Webb's career became apparent, it was clear that a major presentation of his work was long overdue. The present focus on his New York and Paris images stems from the exceptional quality of this work, and its particular need for exposure. While other aspects of Webb's career are not fully known, several key facets of it have received some attention. For example his work in the American Southwest was published in several books from the University of Texas Press in the early 1960s, examples of his commissioned work for Roy Stryker and Standard Oil have been included in recent publications on that project, and his images of Georgia O'Keeffe have been collected in the recent monograph *Georgia O'Keeffe: An Artist's Landscape.* It was therefore determined that an in-depth look at Webb's first two major personal projects — New York in 1945-48 and 1959-60, and Paris in 1948-52 — would constitute the best and freshest introduction to his art for both general audiences and photography specialists.

Through its formal precision and human sensitivity, Todd Webb's work reveals a generosity of spirit, an honesty, and a deep respect for the evidence of time and humanity. As the historian Beaumont Newhall has written, "Todd records what moves him, what fascinates him; he photographs that which defines the character of a place." Webb's photographs do, indeed, define the character of a place while, at the same time, revealing the dimensions of his own character. Due in large part to his reticent personality and extended residence overseas, Todd Webb's eloquent work has been unjustly little known. It is hoped that this exhibition and catalog serve to acquaint a larger audience with his vision, while increasing our understanding of his contributions to 20th century American photography.

Keith F. Davis
Curator, Fine Art Collections
Hallmark Cards, Inc.

A REMINISCENCE:
The New York and Paris Years

by Todd Webb

The photographs in this exhibition were all made to satisfy a need to express myself, not to further any cause, nor to make any editorial statement. They are not the result of any assignment or part of any paid project. The photographs I made for the purpose of earning a living are another part of my life and I feel that they belong to my employers to use as they see fit.

The two cities depicted in this exhibition, New York and Paris, were tremendously moving experiences for me. The first view of each city was so meaningful and exciting that some creative valve within me was released and I was overwhelmed with an obsession to get some of my excitement down on film. I had no plan as to where or what I would photograph. I followed the whim of my vision, the pulse of the city, as it inspired me.

The first of these two big experiences was New York. In November of 1945 I was discharged from the Navy after my tour of duty as a photographer's mate in the South Pacific. My good friends, Harry Callahan and his wife Eleanor, had just moved from Detroit to a small apartment in New York. Harry and I had shared a growing-up in photography together in our native Detroit. When I entered the Navy in 1942 I had left my equipment, which consisted of a 5x7 Deardorff view camera, with Harry. When he and Eleanor moved to New York, Harry brought my

things with him. With some inconvenience to all concerned, we managed to share the apartment and pursue our photographic directions. When Harry was offered a teaching job with Laszlo Moholy-Nagy at the Institute of Design in Chicago, I inherited the apartment. For months I trudged the streets of New York carrying my view camera and tripod on my shoulder, making photographs until my film holders were exhausted and then hurrying home to develop the negatives. While the negatives were drying, I would cook my supper, looking forward to making contact prints before going to bed. It was an exquisitely exciting time of my life. And I have never been poorer.

During my three years in the Navy, I had saved about $2000 and most of this amount I had set aside to get an 8x10 Deardorff and a 4x5 Speed Graphic. I had ordered these two cameras as soon as I got to New York but there was a shortage at that time and I was told I would have to wait at least six months for delivery.

I lived very simply. My apartment rent was $38 a month. I became a member of the 52-20 club. Veterans were allotted 20 dollars a week for 52 weeks after discharge from the service. I had a one-day-a-week job to photograph some of the collection at the Museum of the City of New York for which I received $20, so I had $40 a week to pay my rent and

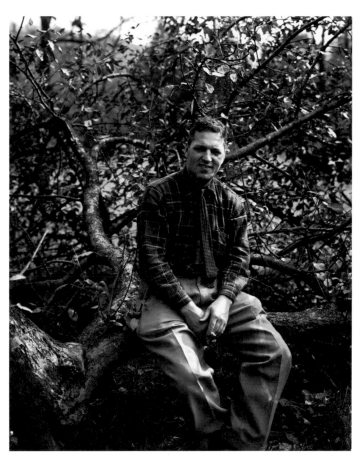

Self-Portrait, New Jersey, 1946

Todd Webb, Maine, 1984 (by Keith F. Davis)

buy my food, which was possible in those days. For my film and chemicals I had to go into my savings.

Before I entered the Navy in 1942, I gave myself a vacation and went to New York at Ansel Adams' suggestion to show some Detroit photographs to Dorothy Norman who, at that time, had her office at Alfred Stieglitz's gallery *An American Place*. I met Stieglitz at that time and we seemed to like each other. When I was in New Guinea I had written him and he answered with a very warming letter and told me

to be sure to come and see him when I returned. Of course, I went to see him as soon as I got to New York. We became good friends and he said that whenever the weather was too foul for photographing, to come and see him. Until his death in July of 1946, I saw him at least once a week. It was during this period that I got to know Georgia O'Keeffe. Often on Friday nights they would invite me to dinner at their apartment on 56th Street. Later, in New Mexico, O'Keeffe told me Stieglitz had said I

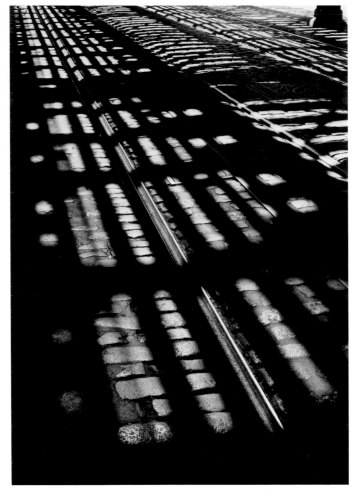

Under the Third Avenue El, New York, 1946

member a woman who once stopped to watch as I was making a photograph of a 'Welcome Home' sign. She politely waited until I came out from under the black cloth to ask what I was taking. I was at a loss to explain so I let her look in the ground glass. The fact that the image was upside down bothered her but finally she saw what was on the glass and was pleased enough to say that it looked very nice. We talked and she told me she was 62 years old and had never been off Manhattan Island and couldn't remember ever having been west of Fifth Avenue. I told her about the nickel subway ride to Coney Island and the nickel boat-ride to Staten Island. She said she would take both trips and tell me about them when next she saw me. I never saw her again and I am still wondering if she ever did go.

When I started out on my daily walks around the city, I never knew where I would go or what I would photograph. Sometimes I passed things I had seen many times, but this time the light was just right to bring it to life and for a few moments, it would be a startlingly beautiful thing to see — and to photograph. Often I went back to make another photograph but it would never be the same without that special light. To this day, when I am photographing for my own pleasure, I work in this same random manner.

Through Beaumont Newhall, to whom Stieglitz had introduced me, I was invited to have a show at the Museum of the City of New York. In September of 1946 an exhibition of 165 photographs, made during the short time I was in New York, went up on the walls of the museum. Grace Mayer, who was then curator of prints at the museum, helped me frame the pictures and she has been a good friend ever since.

The show went up and it seemed to be very popular. The museum had me give a short talk to a group of school kids who visited there as part of a Civics class. And, for the first time in my life, I had a line of people, really kids, waiting for me to autograph one of their books.

It was through this show that I had my first profes-

reminded him of his days as a young man, when he walked the streets of New York photographing.

My favorite street in New York became Third Avenue, endeared to me, I believe, because of the El and the elegant shadows it cast on the rough brick street below. The different neighborhoods of Third Avenue were like small villages in the country. I re-

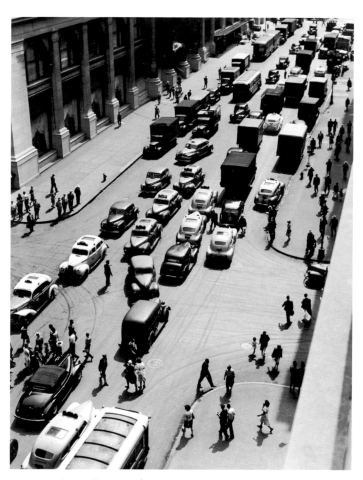

New York Traffic, 1946

Manhattan Traffic Mess," and they wanted me to work with George making photographs of "The Mess." I was terrified but since I had just gotten my "small camera," which is how I referred to my hand-held Speed Graphic, I allowed myself to be talked into trying my first job.

As I was leaving, Debbie Calkins, the Art department coordinator, asked me if I didn't want to talk about money. I had no idea what to ask. She said that they were thinking of $50 a day, which seemed like a lot to me at that time. She mistook the amazement showing on my face for something else and promptly said, "that doesn't mean that you can't make more, we will make that the minimum and figure the job by space used, paying whichever is more". I got out of there in a hurry and reported to George Hunt for work the next morning. George was a gentle and kind man. I am sure he knew I had no idea of what I was doing but he knew I was serious and let me go my own way. I worked my head off, often seeing rather exciting things in "The Mess." I worked three weeks — fifteen days — and was exhausted and not very happy with what I had done. I figured I was lucky to have made $750. When I received my check a few weeks later, I was flabbergasted to see the amount, $1795, with a note saying they wanted me to go to Buffalo on a job about tract housing. That one was not such a success and I was back on the street photographing, one day with my 8x10 and maybe the next with the 4x5 Speed Graphic or feeling more at home with my old 5x7.

A few weeks later I had a telegram from Roy Stryker asking me to come to Rockefeller Center to see him. He said that he had been to see my show and was impressed. Of course, I went to such a 'command performance'. He didn't offer me a job, but suggested that I go back to Detroit and, if I did, that he might have something for me to do out there. I told him, "Thanks, but I want to stay in New York". We shook hands and I left, rather outraged at having been told, for the second time, to go back to Detroit. Paul Strand had told me that once when we were

sional photographic assignment and was also offered a job at the Standard Oil Company by Roy Stryker. While Grace was framing the photographs, a researcher from *Fortune* magazine was looking up some old New Yorkiana, saw the photographs and asked Grace who made them. She wanted my address and a few days later I had a telegram from *Fortune* asking me to come to see them. George Hunt, then a *Fortune* writer, was doing a story on "The

talking at a Newhall party.

Just at the end of 1946, I had another telegram from Stryker saying that he thought he had a job I might like to try. So, on January 8, 1947 I began working for Roy Stryker. A new ESSO building was going up in Rockefeller Center and Roy suggested that I photograph what was going on, what the workmen were like and what kind of materials went into a modern building. He gave me *carte blanche* to do it my own way, and even gave me permission to develop my own negatives, saying that Walker Evans had also insisted on doing that. It was quite an exciting time for me. But everything seemed to go wrong. It was bitter cold and I was certain that an architectural job required the use of a view camera. The cold made my shutters stick and the negatives were almost always over-exposed. When I did have a good negative, something happened in the darkroom. Actually, things were not quite as bad as they seemed to me. Roy even seemed pleased with the results. But, I was very much dissatisfied and after ten days I went to Roy and told him I was quitting and that if I kept on doing such poor work I was afraid it might affect my good feeling about photography. He told me that I couldn't quit and that most of the other photographers working for him had tried the building job and none had done as well as I. He told me to go home and get packed up to go to Portland, Maine for a couple of weeks. An ESSO tanker was going to try to pump heating oil through a pipeline that had been built during the war to carry aviation fuel to Montreal. They wanted to see if it could be utilized to carry heavier oil. While I was in Maine, he suggested that I get some snow photographs for the files.

I arrived by train in Portland in the middle of a February thaw and a dense fog that would not allow the tanker to come into the harbor. For a week the fog did not lift and I amused myself by hanging around the docks and talking to the lobstermen. They steered me to a small dockside restaurant where they served nothing but lobster. For that week my activities were limited to making some photographs of the wet cobblestone streets around the docks and eating lobster two or three times a day. Finally, the fog lifted and I could make the incredibly dull pictures of heating oil being pumped through a pipeline to Montreal. By that time, the last vestiges of snow had disappeared and I was disgusted with working for Standard Oil. Also, in eating all that lobster, I had gained fifteen pounds. I got a sleeper on the train back to New York. As the train pulled out of the yard at Portland, it began to snow and when I arrived in New York the next morning, a *New York Times* headline told of the blizzard that had struck Maine during the night. I was certain that I would be fired and could avoid the redundancy of quitting again.

Surprisingly, a couple of the pictures of the tanker poking through the fog and my wet pavement photographs pleased Roy very much and I didn't have to quit again. However, I was very concerned and worried about what effect working for Standard Oil might have on my feeling about photography. I have looked back through the journal I kept at that time and the concern and worry dominated what I wrote.

Eventually I came to terms with earning a living with photography and I had made my peace with Roy so things were better. I worked all of 1947 on Standard Oil projects. An ice jam on the Ohio River, a documentation of Philadelphia and a long stint in Louisiana, photographing the big refinery at Baton Rouge, the movement of oil by barge on the Mississippi River and finally, the still photographs for Robert Flaherty's *Louisiana Story*. In between jobs I continued to walk the streets of New York, making my own photographs, which I still considered the most important part of my work.

After Louisiana and back in New York, I went off to spend six weeks in New England for Roy. I had bought a car and Roy asked me what I knew about New England. When I said, "very little" he replied, "Why don't you get in your car and travel around New England and let me see what it looks like". That

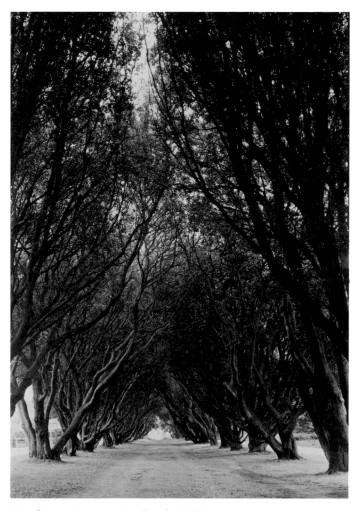

Worthing, Sussex, England, 1948

was the wonderful thing about working for him. He never did assign me to anything specific but allowed me to find my own way. After that, I went back to Abbeville, Louisiana to finish the work for *Louisiana Story* and do some more "looking around to show what the country was like".

When I got back to New York in February, the street where I lived was still buried by the snow that had fallen on Christmas Eve and overflowing garbage cans lined the unshoveled sidewalks. I spent a couple of weeks in New York getting my captions written and whenever I had time I went out to photograph on my own. My next assignment was to photograph Pittsburgh as I saw it just before the big civic campaign began to clean up the city.

By this time Roy's budget was quite drastically cut, Standard Oil Company's image having been improved. The staff was told that Roy would appreciate it if we could manage to find some other work when it was available. While I was in Pittsburgh, I had a call from Rene Leonhardt who ran a color agency called *Cameraclix*, with offices in New York and London. He offered me a job to make 5x7 Kodachrome transparencies of the English countryside in the summer of 1948.

I was happy to accept the job and on the first of May I was off to England on the *S.S. Veendam* for my first view of Europe. It was the rainiest summer in the history of British weather records and it was late October before I got back to New York. It was a successful trip in spite of the weather but the best part was the two weeks in Paris that Rene gave me as a bonus for a job well done. I had another love affair with a city — Paris. As soon as I returned to New York I began to plan on how to return to Paris.

I went to see all of the editors I knew and Roy promised me three months of work in Western Europe. In mid-February, I was back in Paris hoping to stay for six months. Four years later, I was still there.

Those two weeks in Paris in 1948 were more exciting than any two weeks I had experienced. I found a room in a small hotel on Rue Jacob, close to St. Germain des Pres which, at that time, was a wonderful location. I had my 5x7 view camera and a good stock of cut film. I would start out from the hotel every morning with my ten holders full of film. That Left Bank neighborhood was rich in things to photograph and I hardly got away from it except for a couple of trips by metro to Montmartre. I had been told

that I must see the Champs Elysees and in the morning I often started walking that way. However, I always ran out of film somewhere around the Place de la Concorde and got back to London without ever seeing the Champs Elysees and that was hard to explain to my Francophile friends in London and New York.

Before I returned to Paris in 1949, I bought one of those tiny Renault *quatre-chevaux* in New York for delivery in Paris. At first I stayed in my small Left Bank hotel, but after a month or so I found a service flat in the Porte d'Orleans section of Paris. It was near the studio of my sculptor friend, Mary Callery, whom I had known in New York. In April, I met Lucille who was revisiting Paris where she had gone to school as a girl. One of the people she was traveling with had known me in New York and looked me up. Lucille and I fell in love and corresponded after she returned to New York. In September, she came back to Paris and we were married in the mairie of the 14th *arrondissement* with Mary Callery and Peter Maas as our witnesses. Soon after, Mary wanted to go back to New York and asked if we would care to rent her studio for a year. We did and stayed on for four years until 1952 when she had the urge to live and work in Paris again and we were feeling the need to get back home. Mary was considered a distinguished citizen of France for the services she rendered the country in World War II. It had been a great time for us and I had been very productive. I had quite a few jobs for the Marshall Plan and could work as much as I wished as long as payment in francs was acceptable. Living as we were, I had no objection to francs. The pay at ECA was the franc equivalent of $50 a day, with the exchange rate at about four hundred francs to the dollar. Rents were frozen in France and our studio rental ran to about $140 a year. Food and recreation also came at bargain prices. Of course, I had a lot of time to work on my personal projects.

Coming home on the *Ile de France* and passing the Statue of Liberty in New York Harbor was an affecting moment. Getting settled in New York and or-

Lucille in our Studio Dining Room, Paris, 1950

ganizing our lives to the hectic pace of the bustling city was not so thrilling at first. Finally, we were settled into a third floor apartment on St. Luke's Place in Greenwich Village and life adjusted to a routine. Whenever I had spare time I indulged my passion for making photographs of New York.

I got interested in the Western Expansion of the 1840s and in the fall of 1954 applied for a Guggenheim Fellowship to do a photographic study of the Westward Trails used by the '49ers in the Gold Rush, and the pioneers who settled in Oregon dur-

12

Studio Stove, Paris, 1950

velous Huck Finn experience that I will never forget. I hadn't walked far into Kansas when I found the towns too far apart for walking so, at Great Bend, Kansas I bought a three-speed bicycle and pedaled my way to Santa Fe along the old Santa Fe Trail that my New Yorkers had followed.

I stopped to visit O'Keeffe in Abiquiu and she insisted that I stay and get fattened up a little before starting across the mountains and deserts of the West. A friend of Georgia's had just bought a new Vespa and had taken a spill on her first ride and about the time I arrived she was trying to sell it. I bought it and finished my trip on that wonderful little bike. Even though I cheated and did not walk all of the route, the trip took me about six months. It seemed like a miracle when I flew back to New York in seven hours. An even bigger miracle happened when the people at the Guggenheim Foundation thought I should have another grant to complete my study in 1956.

Organizing my material and interviewing publishers kept me busy for the next couple of years. I did some photographic work for an ad agency and in 1956 had a contract with the United Nations to document the General Assembly meeting which at that time lasted only the month of September. My contract with them was renewed yearly through 1960. I had other assignments from them out of the country, including a trip to Mexico and then, in 1958, a six-month tour of African countries south of the Sahara Desert to do a survey on the economic possibilities of emerging nations.

I began to see that our post-Paris stay in New York was coming to an end. Every summer, with the exception of 1958 when I was in Africa, we had been invited by O'Keeffe to spend our vacation in New Mexico, either at her Abiquiu house or the Ghost Ranch. We became entranced with the idea of living in New Mexico. The idea became a reality when our house on St. Luke's Place was sold to Arthur Lawrence, the man who wrote *West Side Story*, and that seemed like a good excuse to make our way to Santa

13

ing the same period. I planned to walk along the routes used by the westward travelers photographing the sites and country they had described in the diaries they kept along the route. I was given a grant and in April 1955 began my walk to Pittsburgh, using the diaries of a group of New Yorkers who went to the Gold Rush in 1849. At Pittsburgh, I bought a 16-foot skiff and the Evinrude Company loaned me an outboard motor so I could follow the river route used by the travelers from Pittsburgh to Independence, Missouri. It was a mar-

Cash Entry Mining Office, Cerrillos, New Mexico, 1964

Georgia O'Keeffe in Juan Hamilton's Studio, Barranca, New Mexico, 1981

Fe. So, in January of 1961 we said farewell to one of our favorite cities and moved to a totally new environment which would add another dimension to my career as a photographer.

This marked the end of my close relationship with my two favorite cities. We see them now once or twice a year for short visits. That's not like living in one of them but it does stir up lots of wonderful old memories. These short visits convince me that I was right when I used to say, "New York is a wonderful place to live but a bad place to visit". And the same goes for Paris. When you live in a big city, you can always go home and close the door and be quiet and private. When you visit, you are torn between getting everything done and watching the hotel bill go through the roof. Then one of the greatest pleasures is to return home to peace and quiet.

After ten years in Santa Fe, we returned to France for four years to live in a small village of 195 people in Provence. Now we live in Maine.

NEW YORK

1945-1959

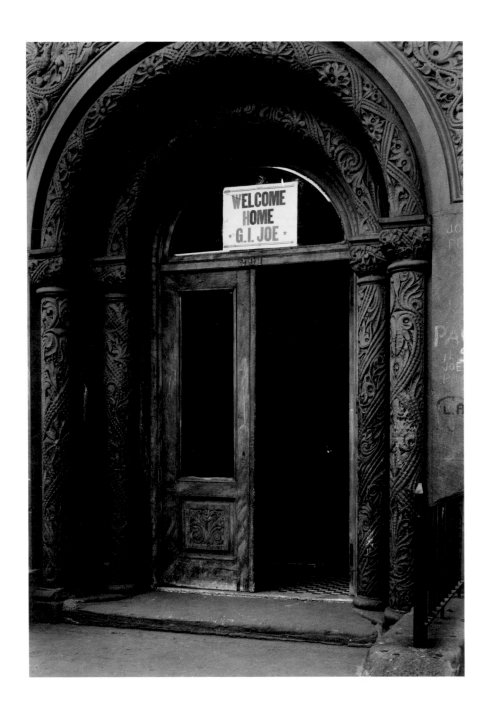

Welcome Home Series: 8th Street, New York, 1946

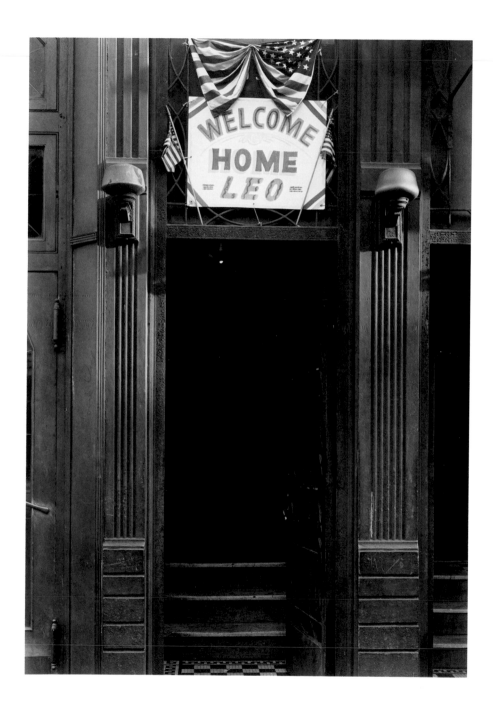

Welcome Home Series: Third Avenue, New York, 1945

18

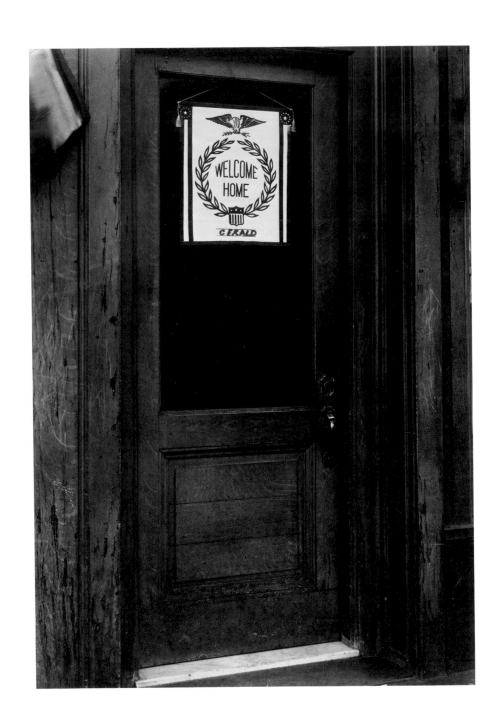

Welcome Home Series: Third Avenue, New York, 1945

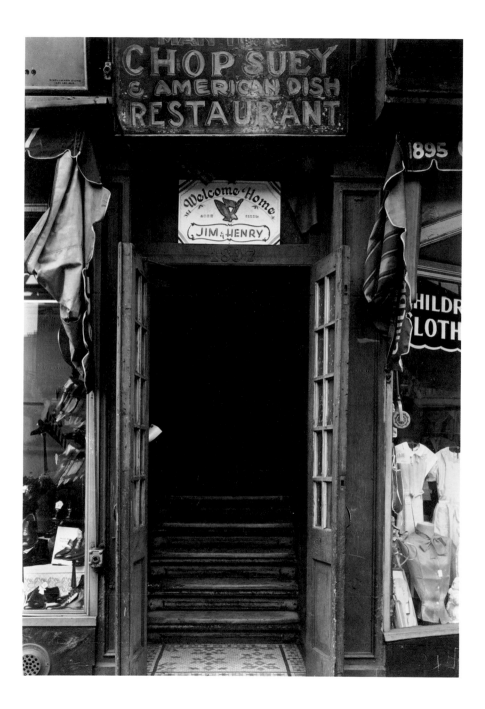

Welcome Home Series: Third Avenue, New York, 1945

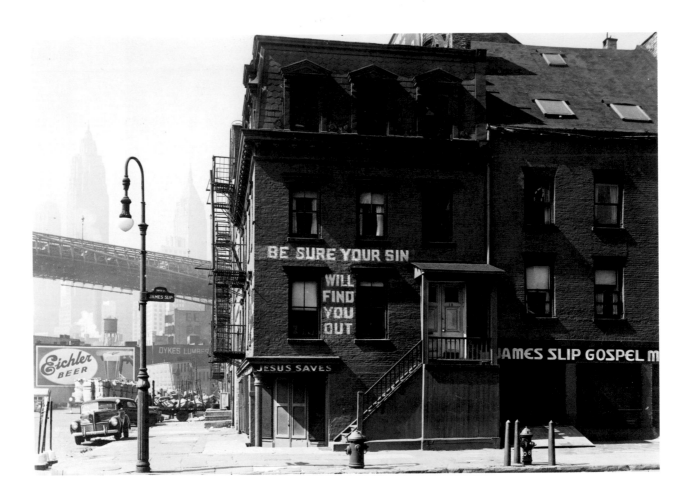

James Slip, New York, 1946

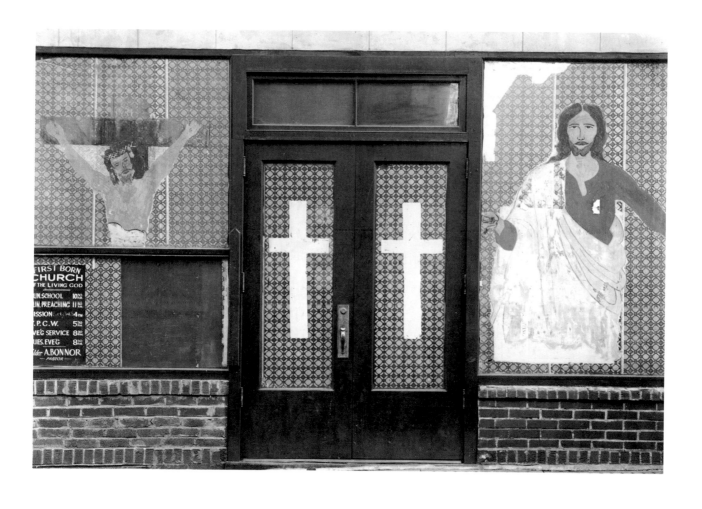

Church in Store, Third Avenue, New York, 1945

Church in Store, Harlem, New York, 1946

Church in Store, Harlem, New York, 1946

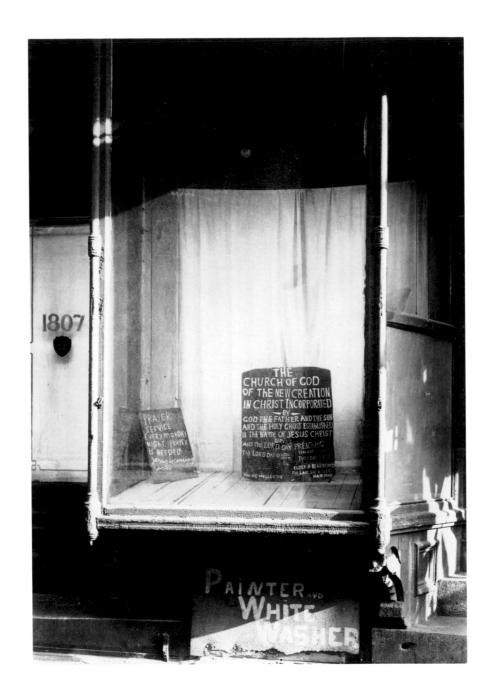

Church in Store, Third Avenue, New York, 1945

Church in Store, Third Avenue, New York, 1946

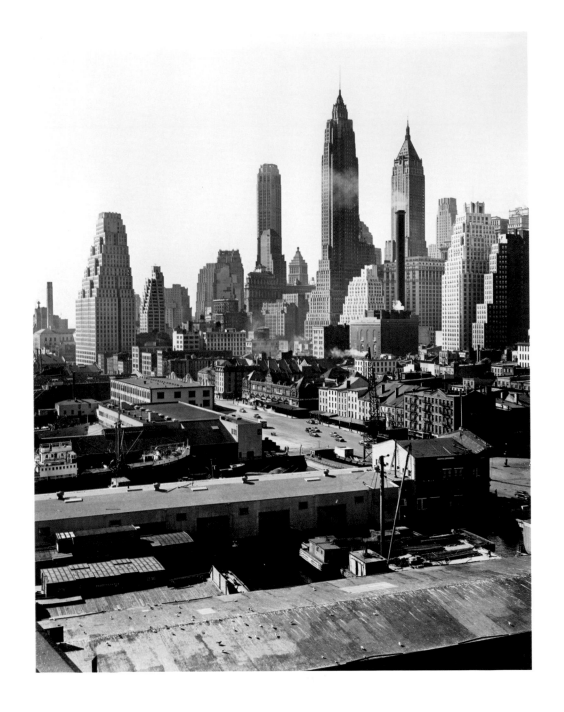

Lower Manhattan from Brooklyn Bridge, New York, 1946

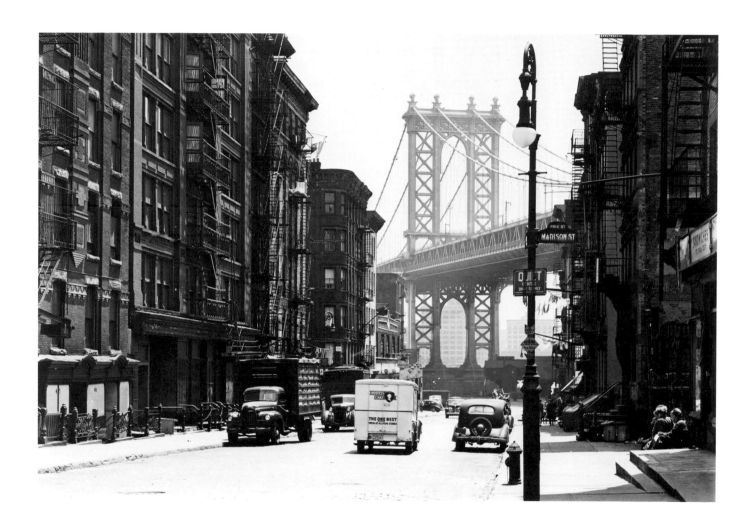

Manhattan Bridge from Madison and Pike Streets, New York, 1946

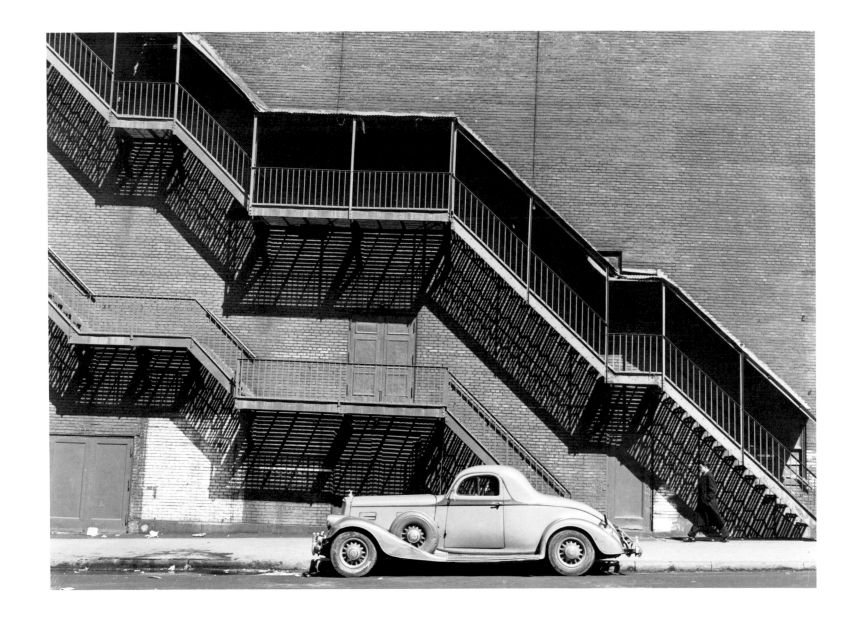

Mr. Perkin's Pierce Arrow, Harlem, New York, 1946

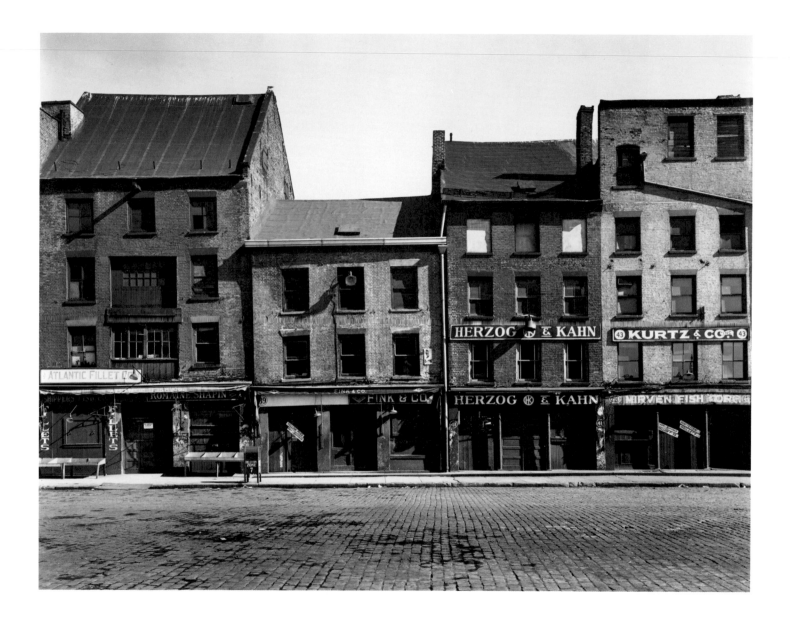

Peck's Slip, New York, 1946

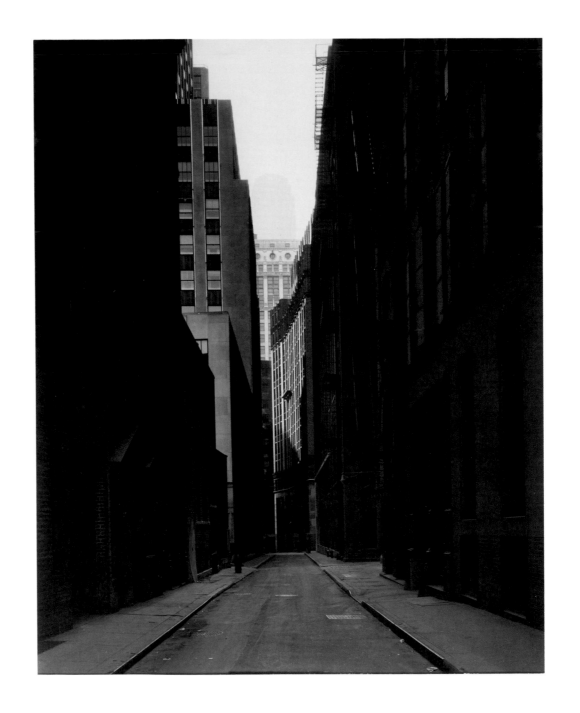

Gold Street, New York, December, 1948

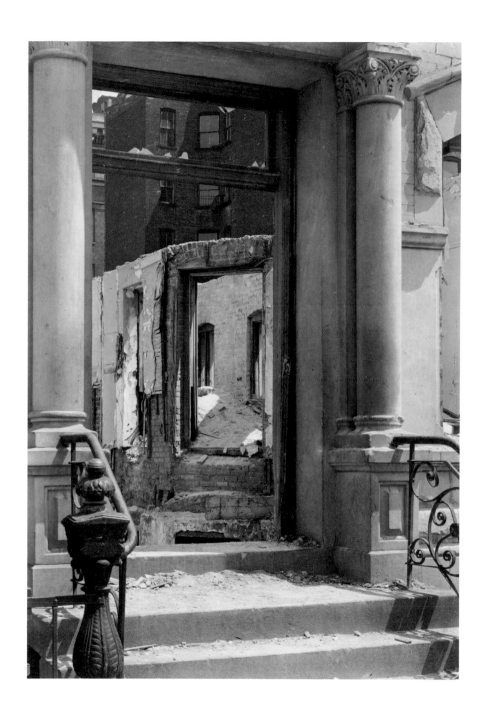

Slum Clearance, Harlem, New York, 1946

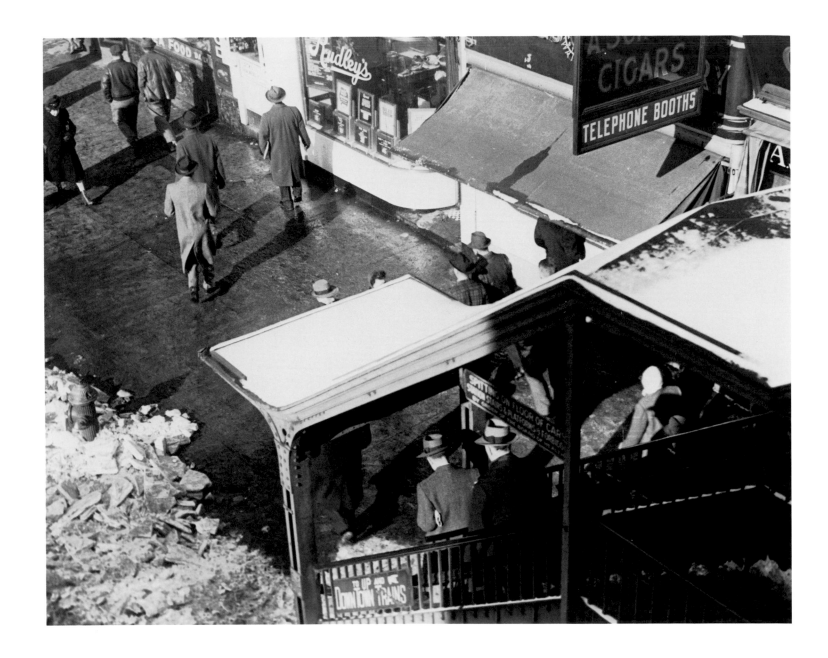

42nd Street El Station, New York, 1945

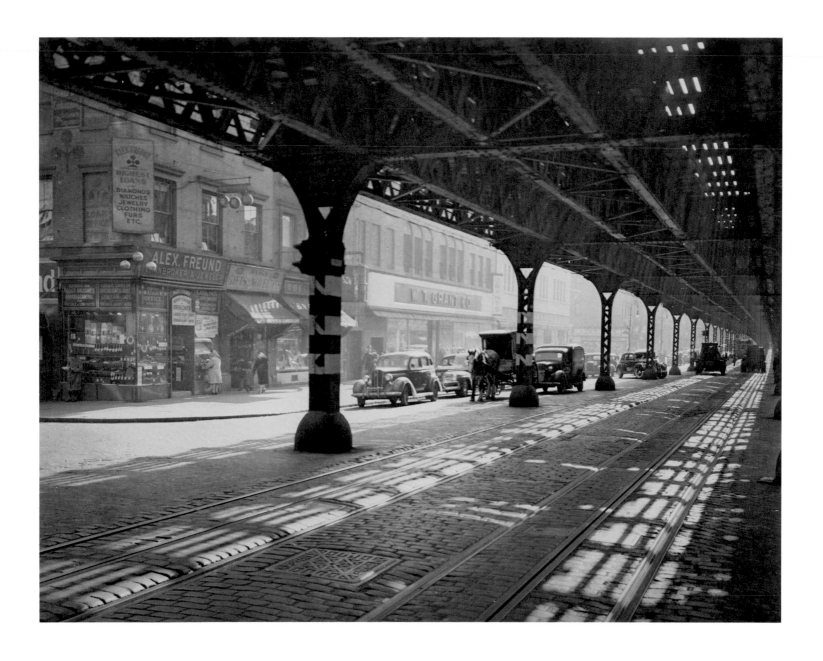

Third Avenue, New York, 1946

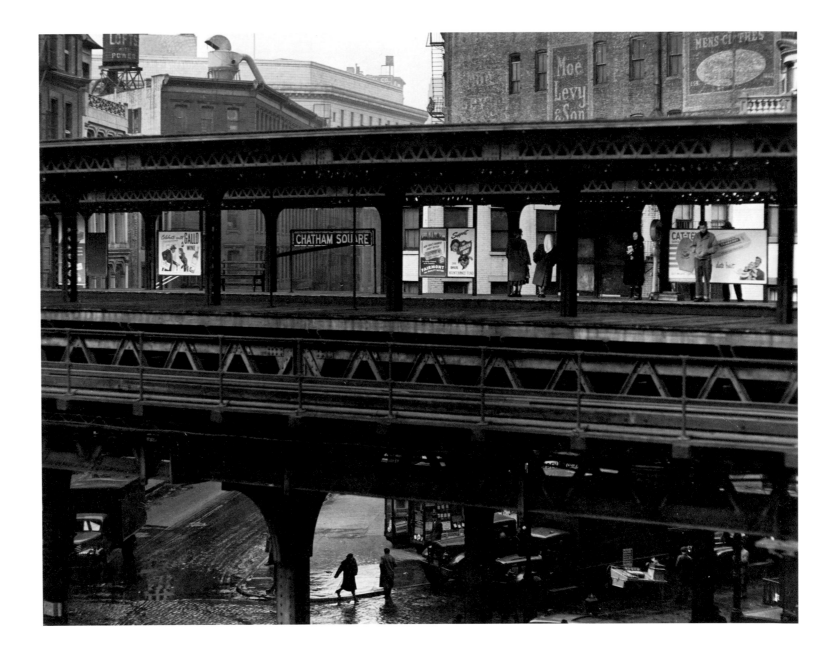

Chatham Square, New York, 1946

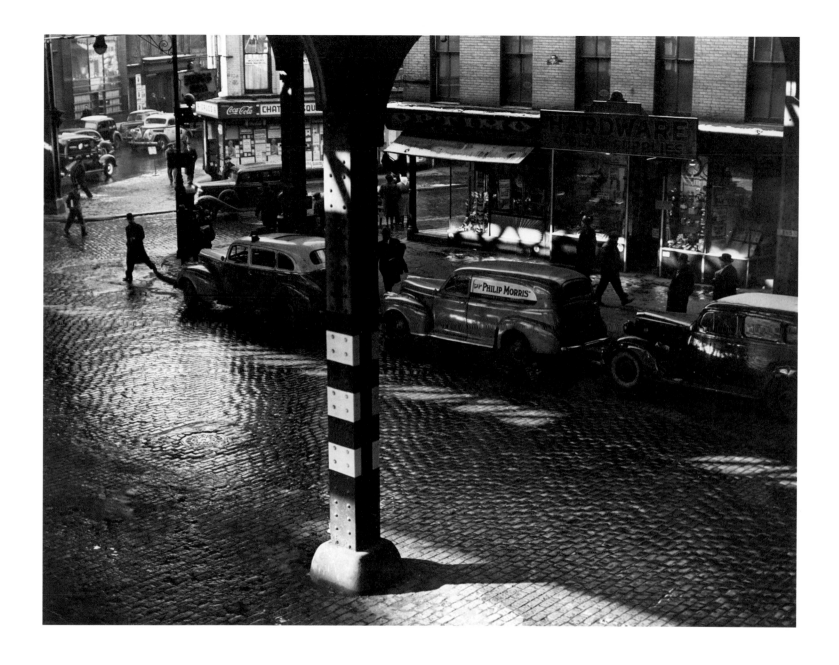

Chatham Square, New York, 1946

Harlem, New York, 1946

New York, 1946

Billboard on Third Avenue, New York, 1946

106th Street, New York, 1946

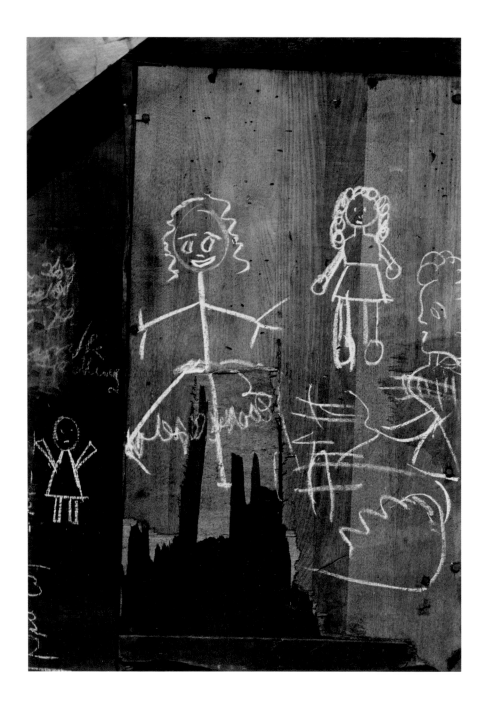

125th Street, New York, 1946

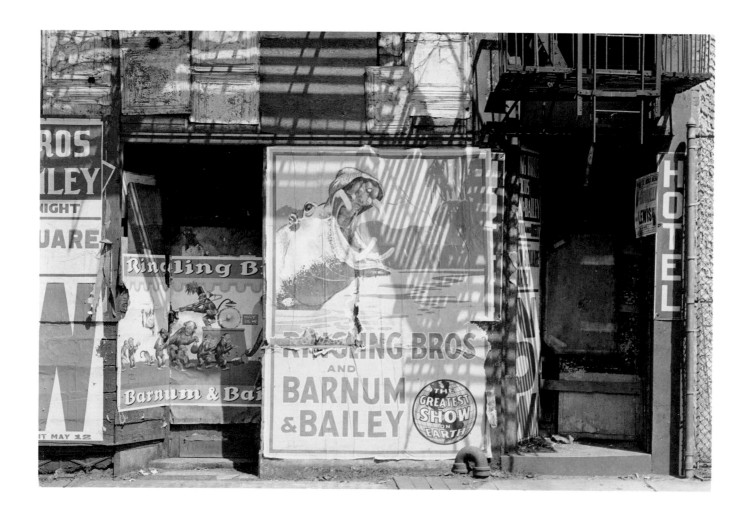

Eldredge Street Near Canal, New York, 1946

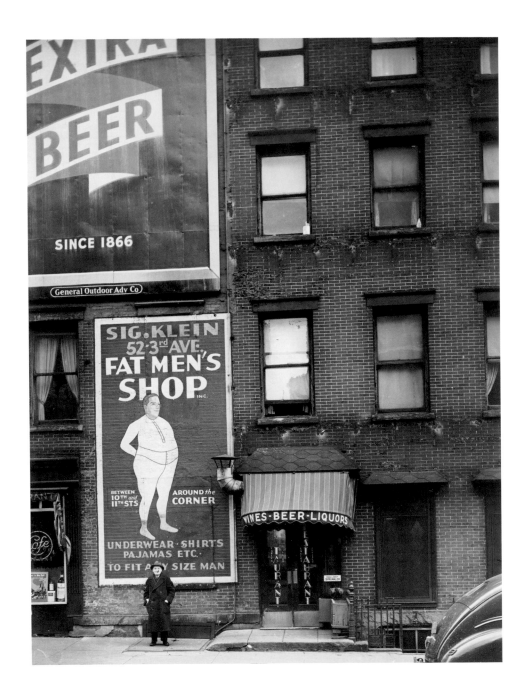

Third Avenue, New York, 1946

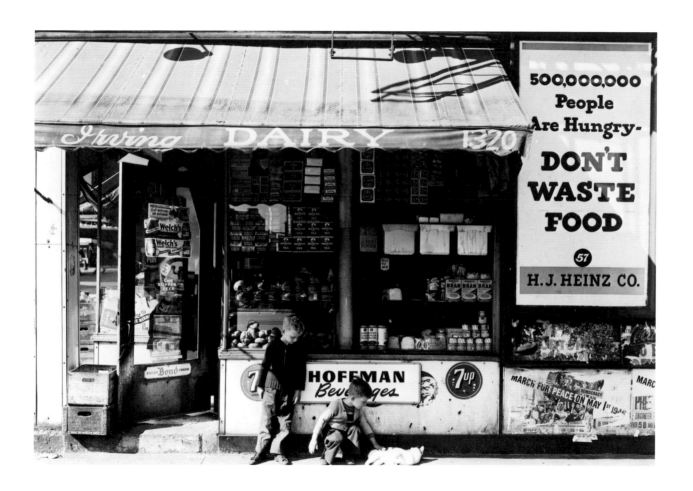

LaSalle Street at Amsterdam, New York, 1946

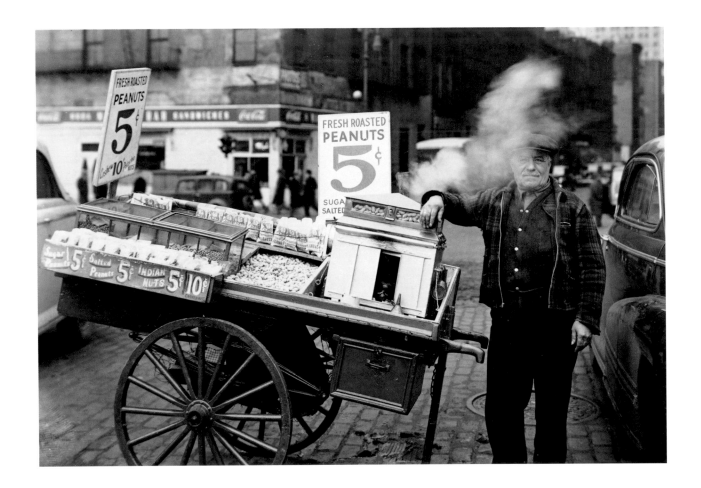

The Battery, New York, 1945

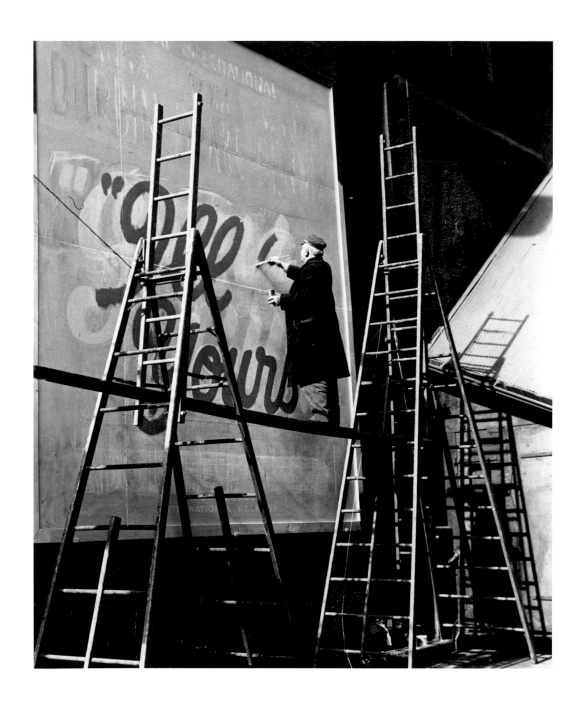

Times Square, New York, 1946

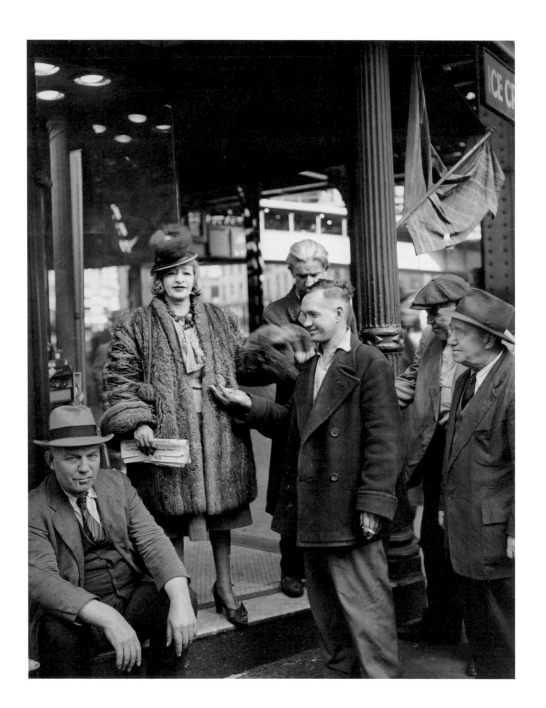

Masie, Queen of the Bowery, New York, 1946

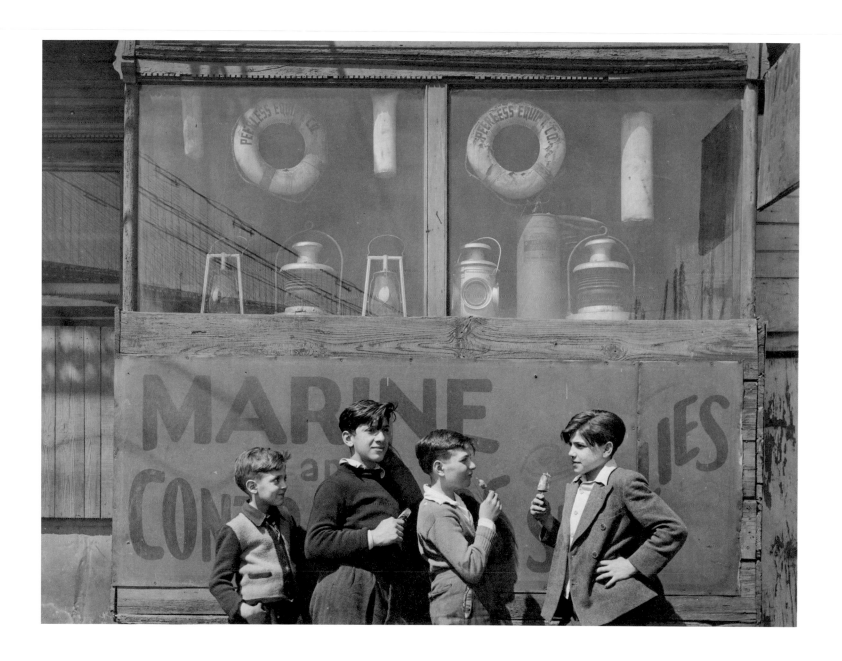

Near Fulton Fish Market, New York, 1946

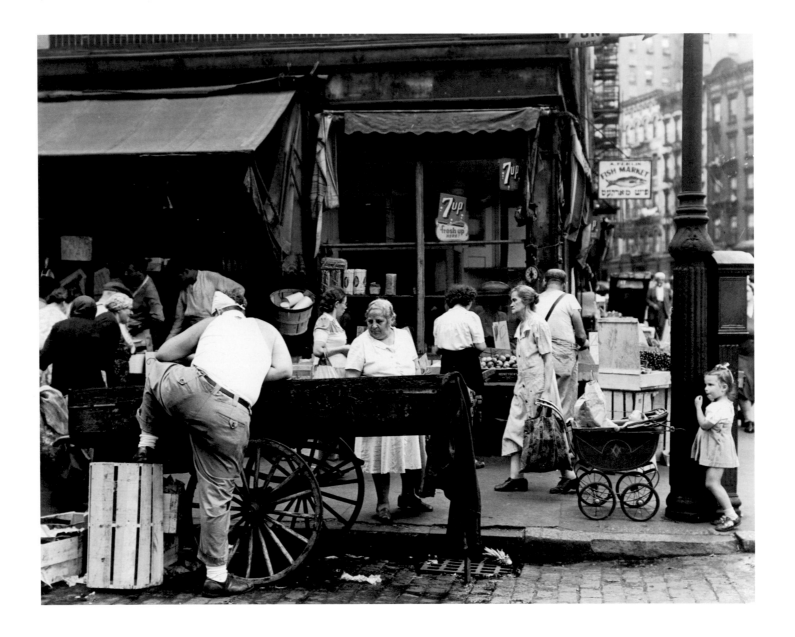

Street Market, Suffolk Street, New York, 1946

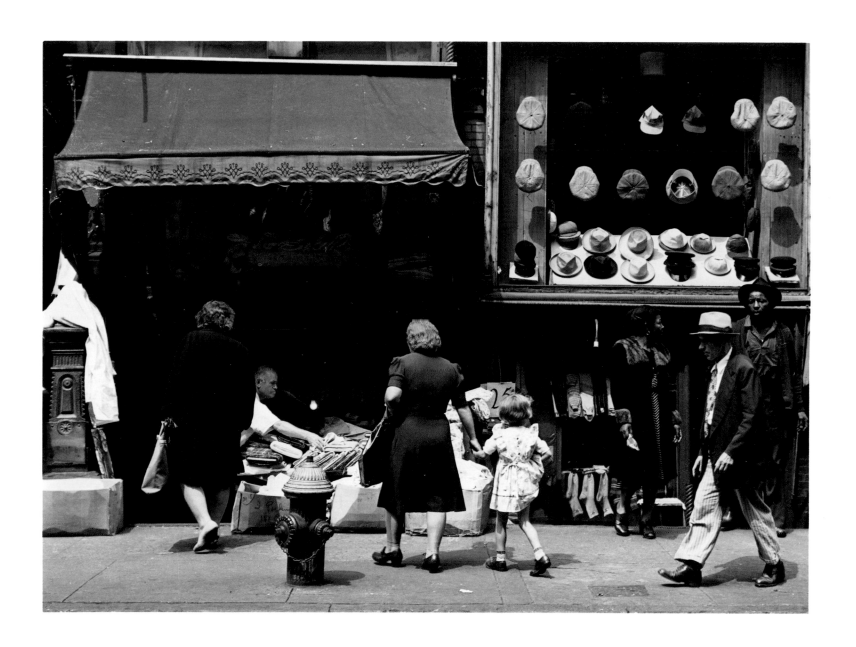

Orchard Street, Lower East Side, New York, 1946

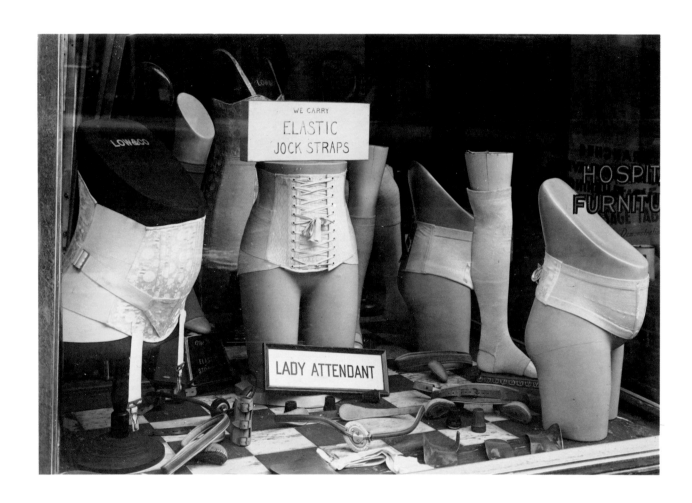

Third Avenue, New York, 1946

Internal Revenue Building, Lower Manhattan, New York, 1946

Fisherman's Store, Fulton Street, New York, 1948

Amsterdam Avenue, New York, 1946

Nassau Street near Fulton, New York, 1959

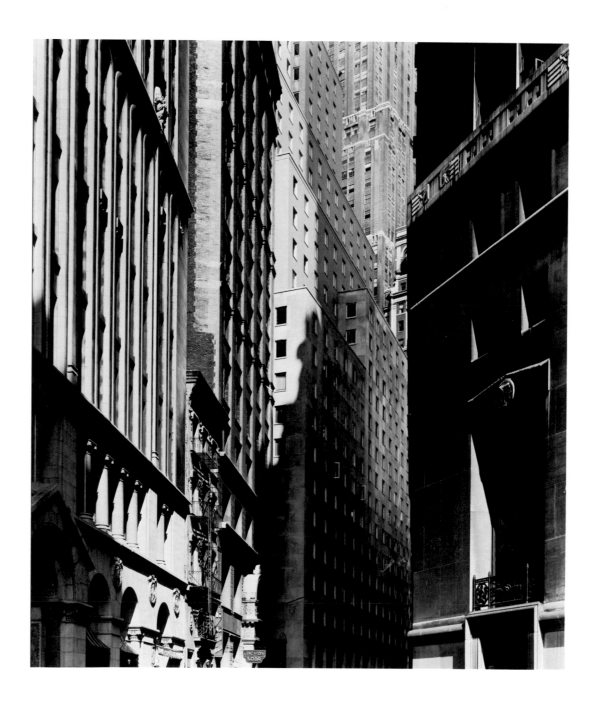

Lower Manhattan, 1959

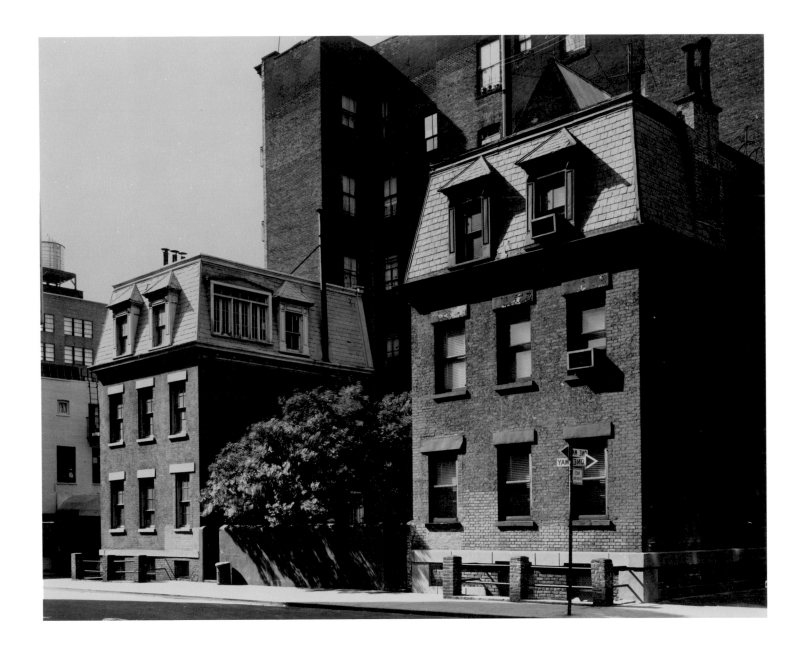

Between Commerce and Barrow Streets, Greenwich Village,
New York, 1959

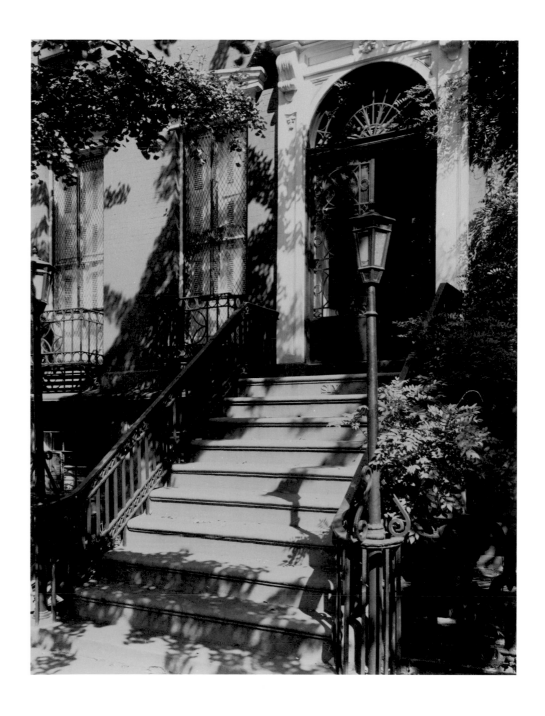

Mayor Jimmie Walker's Old House, St. Luke's Place,
New York, 1959

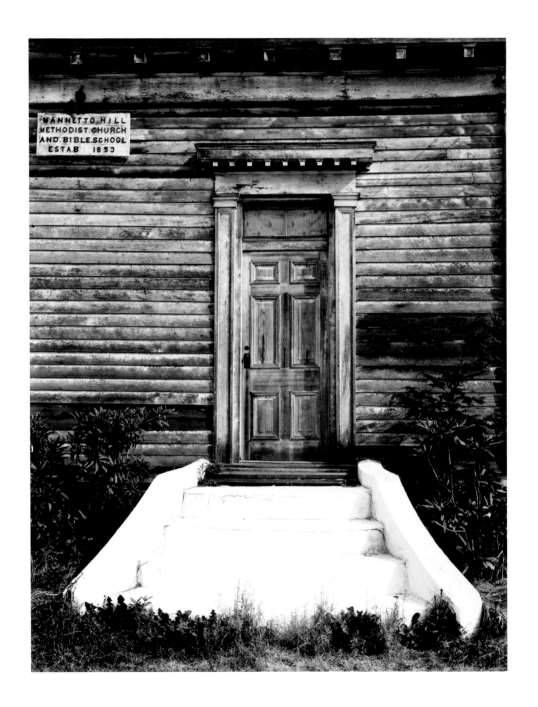

Church near Hicksville, Long Island, New York, 1952

Paris

1948-1952

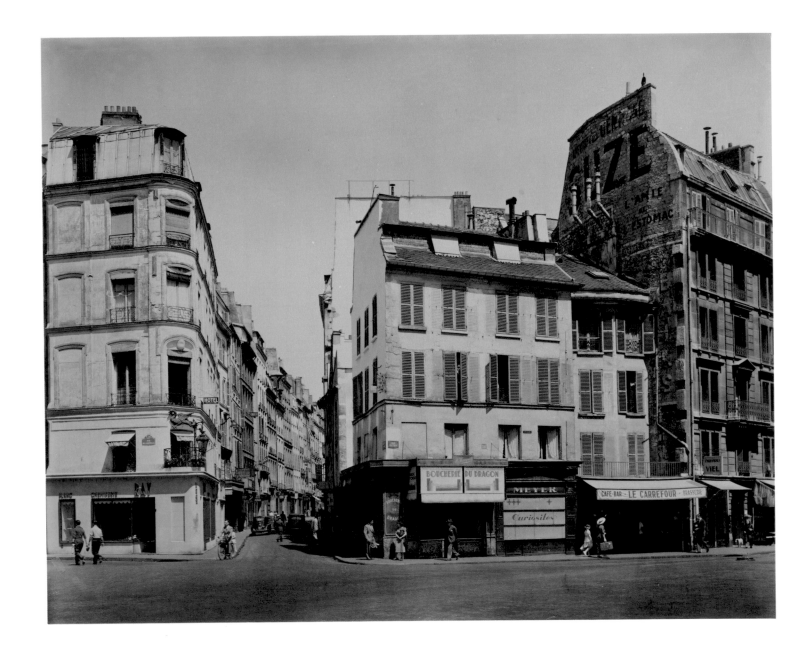

Rue du Four, Paris, 1951

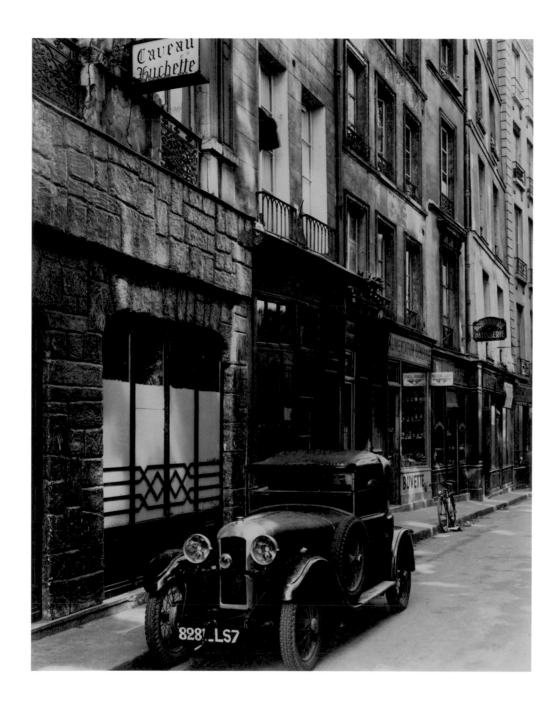

Rue de la Huchette, Paris, 1949

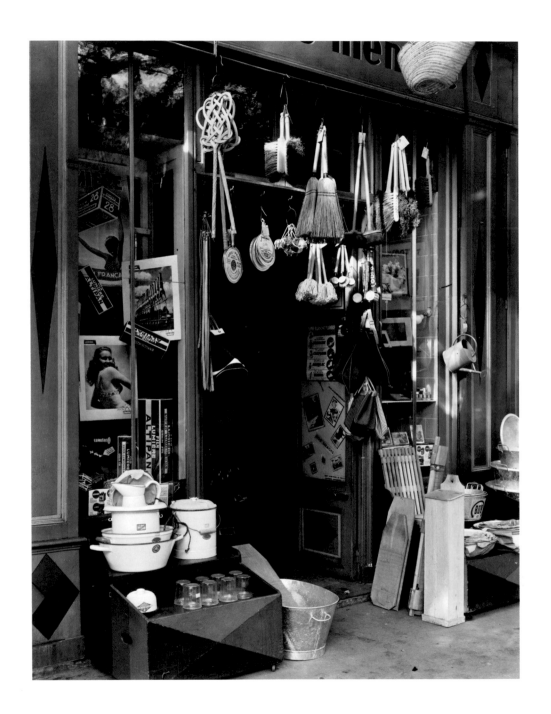

Variety Store, Rue Alesia, Paris, 1949

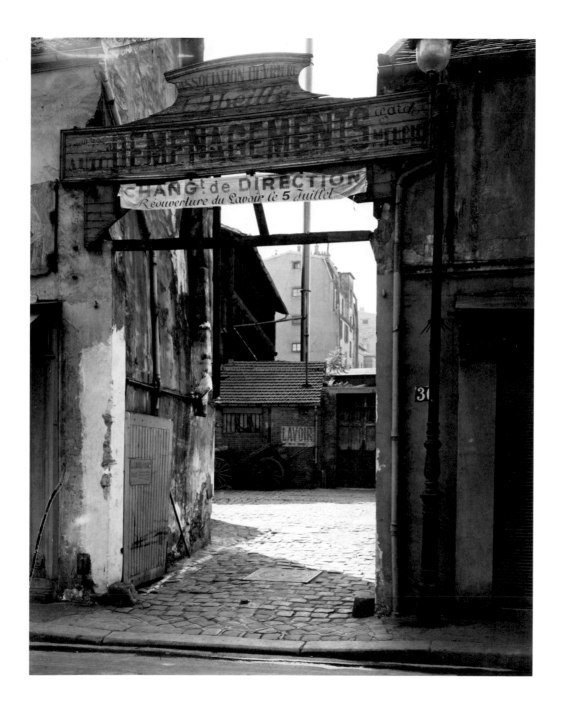

Rue des Plantes, Paris, 1949

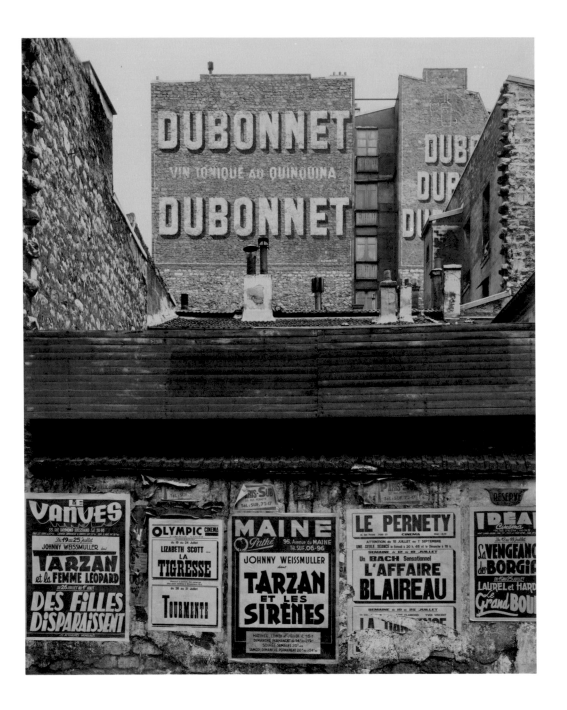

Paris, 1950

Left Bank Hotel, Paris, 1949

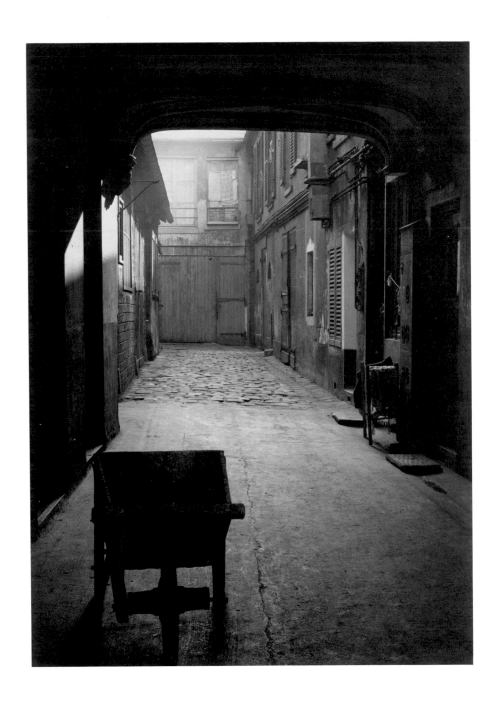

Paris, 1948

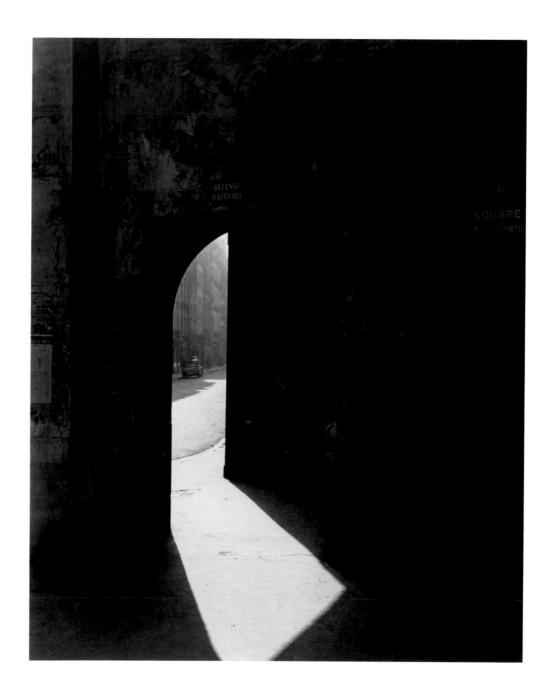

Passage to Rue de Seine, Paris, 1949

Paris, 1949

Paint Store, Paris, 1949

Shoemaker, Paris, 1950

Left Bank Barber Shop, Paris, 1949

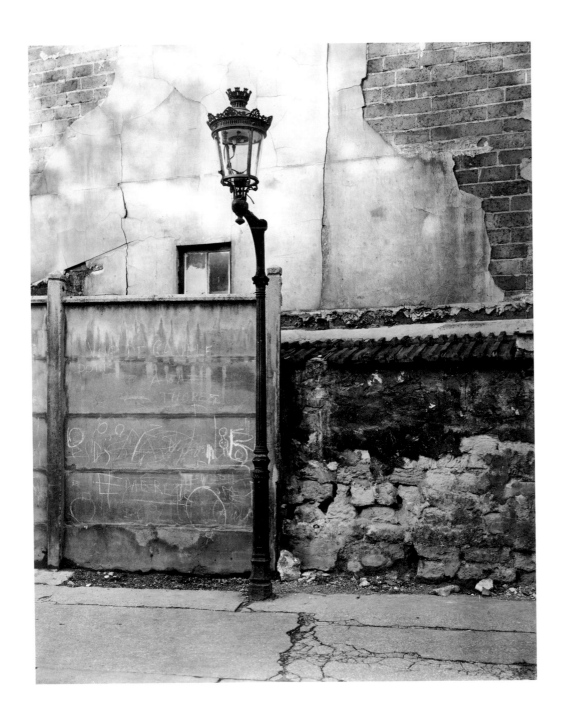

Paris, 1950

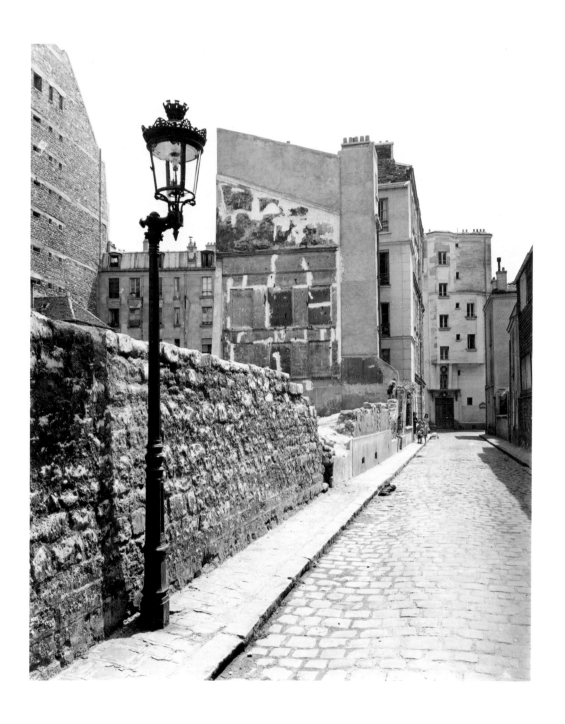

Passage de Moulin Vert, Paris, 1950

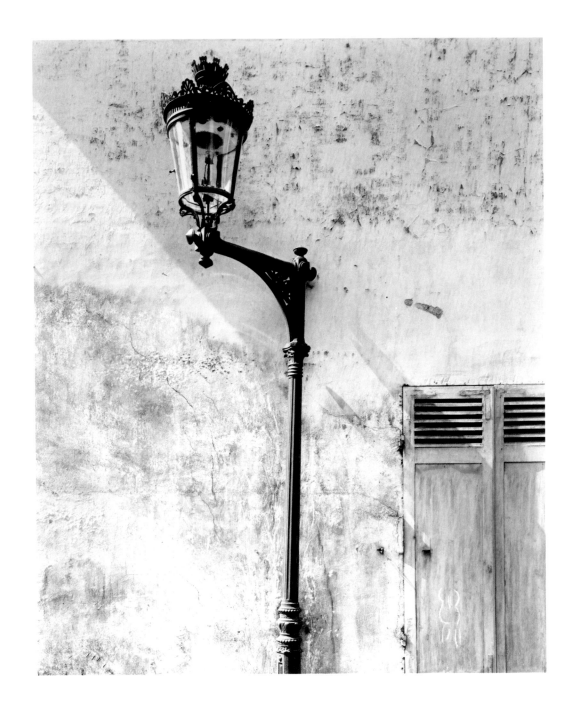

76

From "Lamps of Paris" Series, Paris, 1950

Lamp at the Paris Opera, Paris, 1951

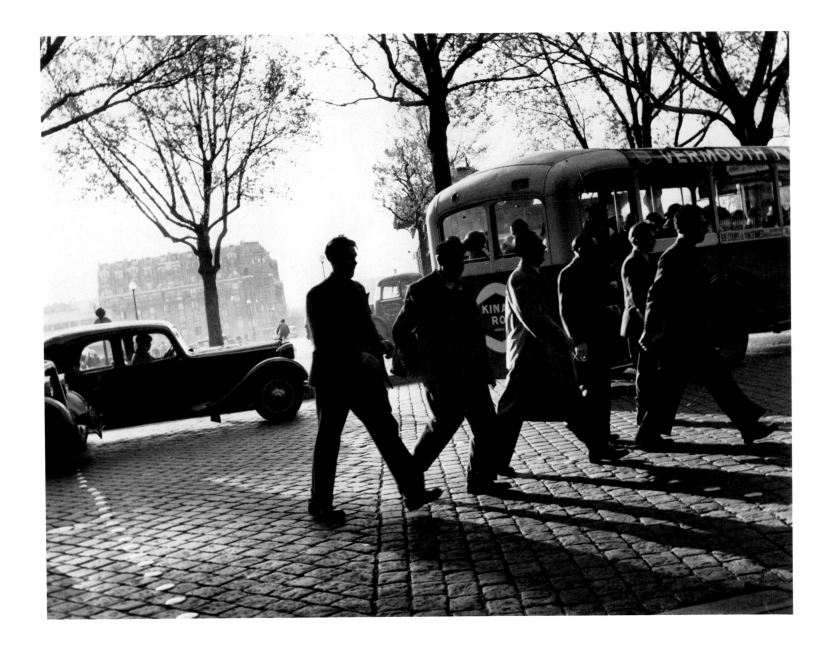

Paris, 1951

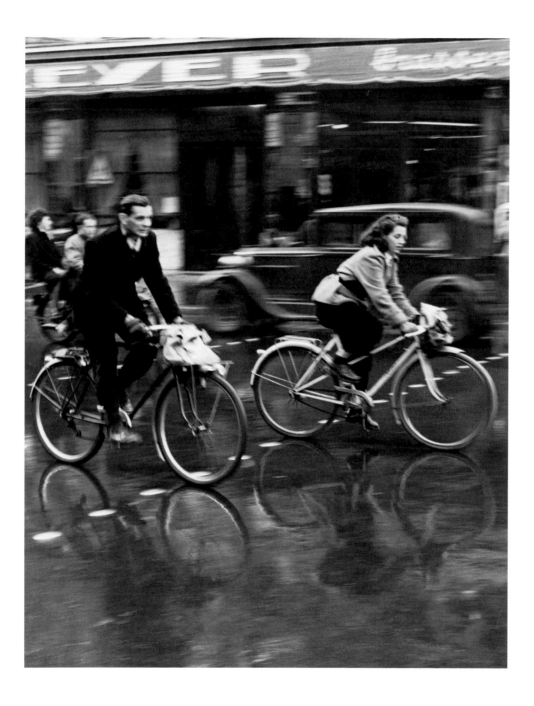

Alesia, Paris, 1950

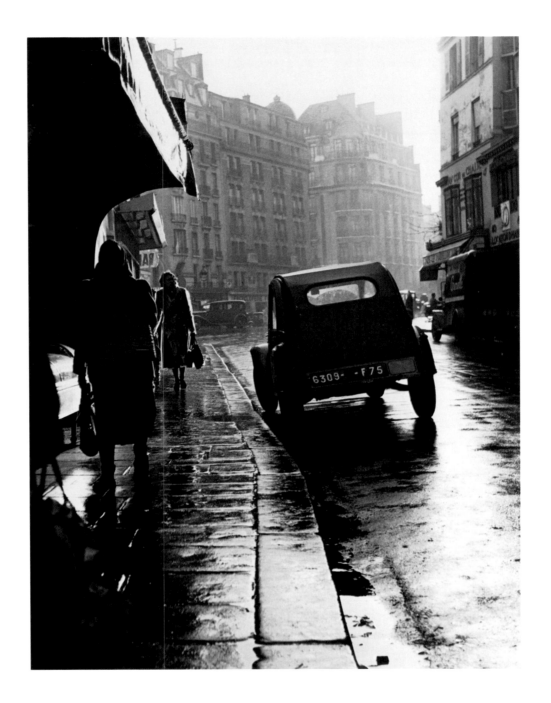

Rue des Plantes, Paris, 1950

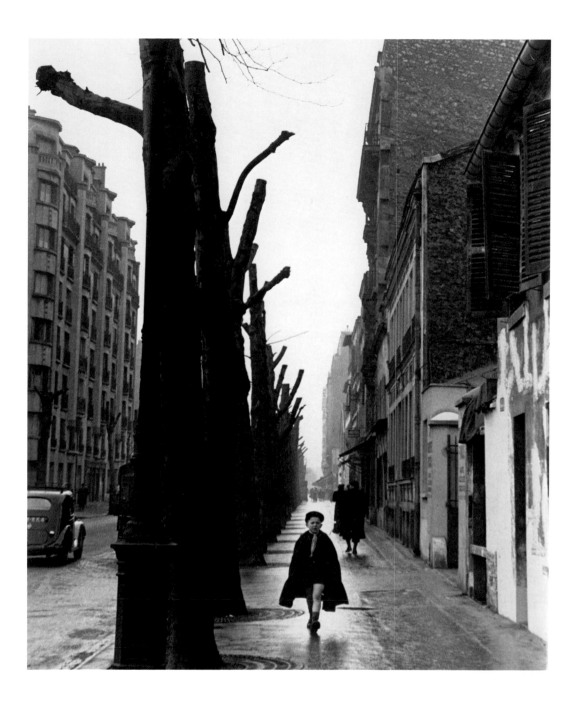

Rue de Chatillon, Paris, 1949

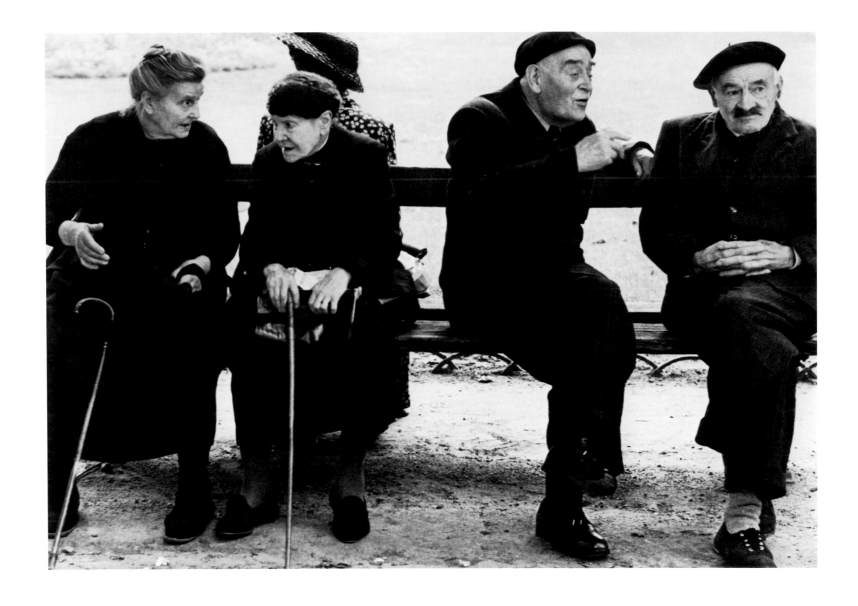

Luxembourg Gardens, Paris, 1949

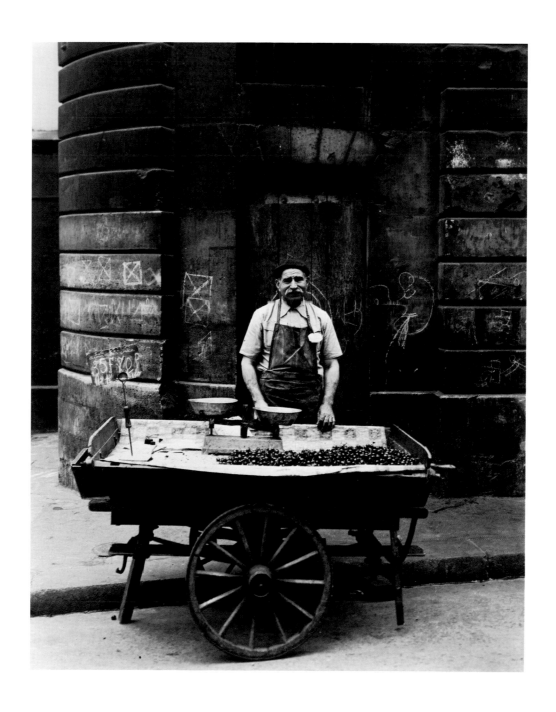

Cherry Man, Rue Mouffetard, Paris, 1950

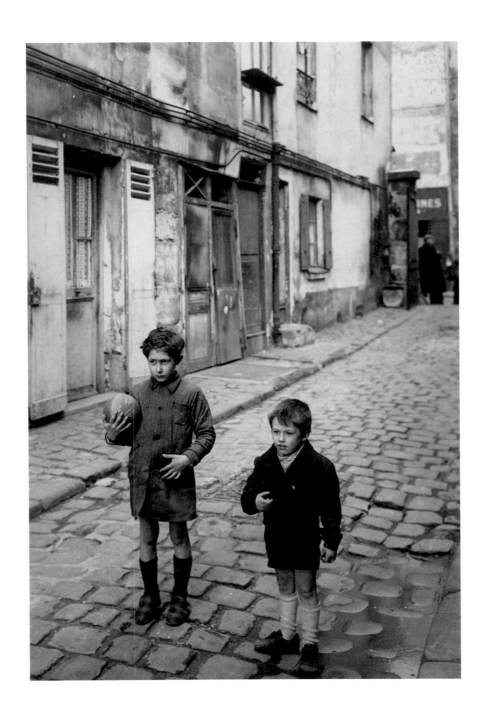

Children, Montparnasse, Paris, 1950

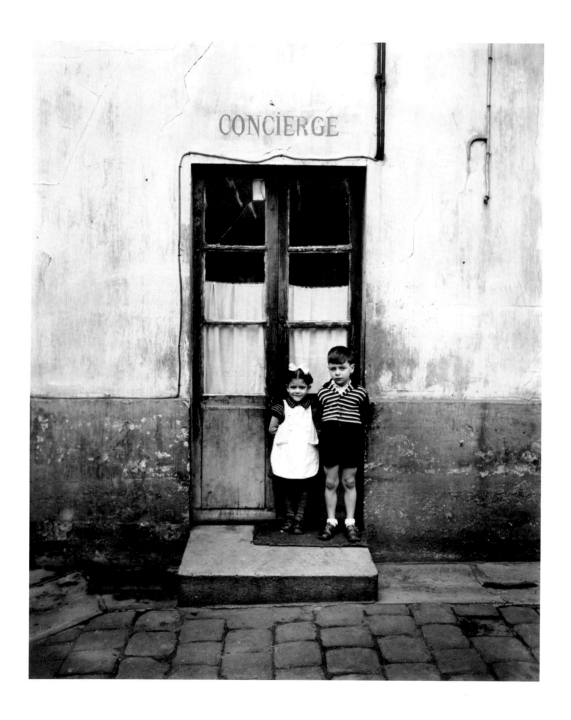

Left Bank, Paris, 1949

Rue Alesia, Paris, 1949

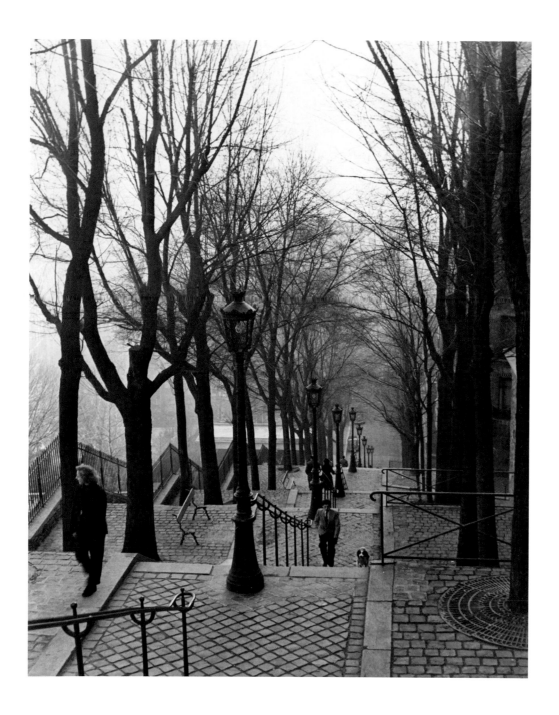

Walk Down from Montmartre, Paris, 1949

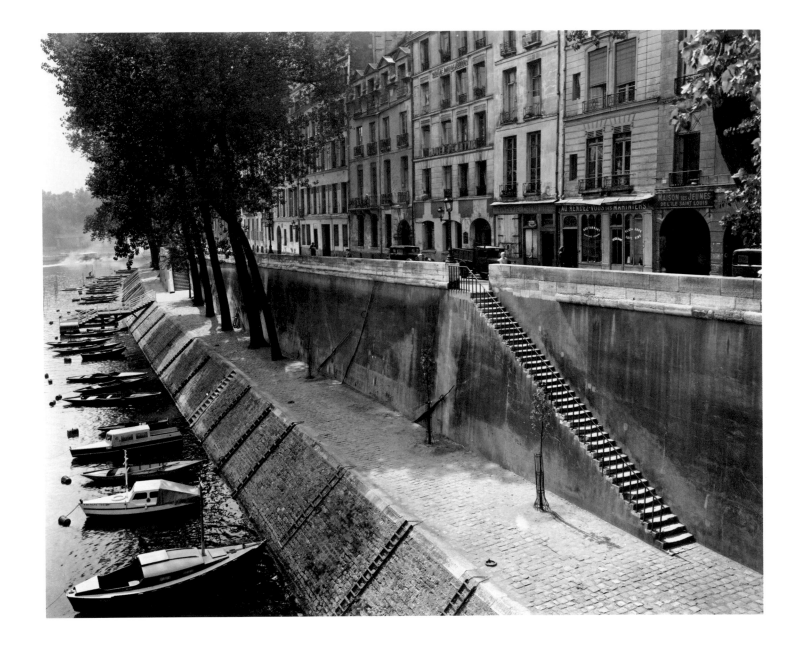

Quai Bourbon, Ile St. Louis, Paris, 1950

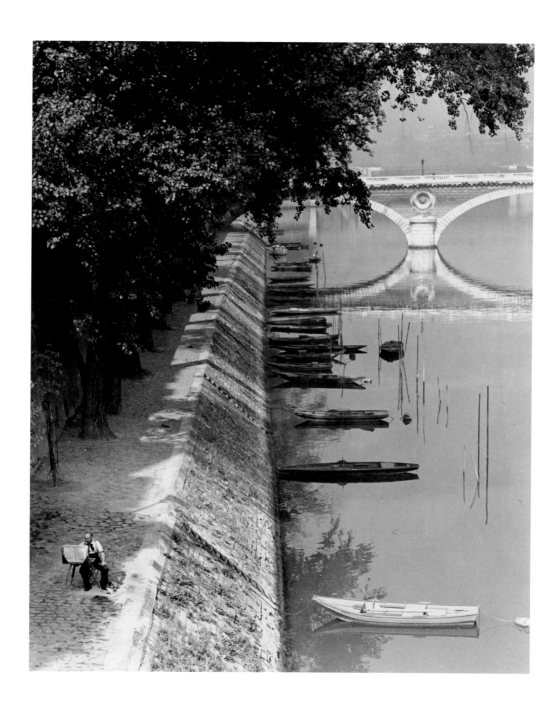

Quai Bourbon, Ile St. Louis, Paris, 1951

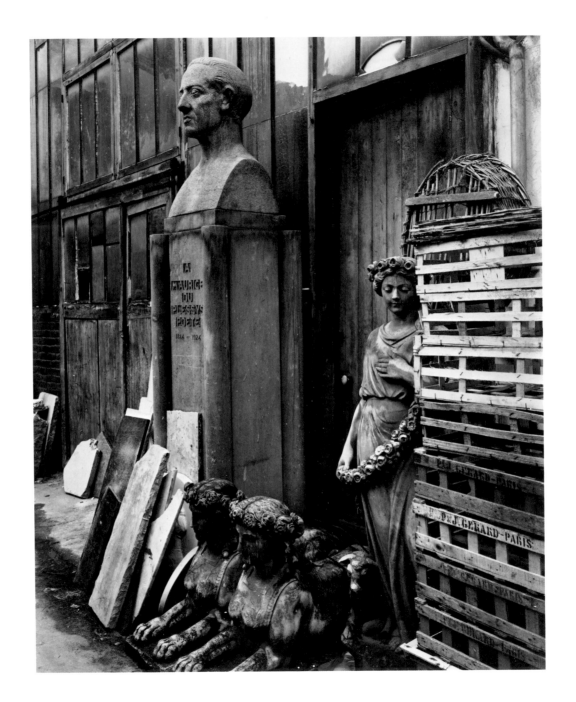

Rue des Plantes, Paris, 1950

Left Bank, Paris, 1948

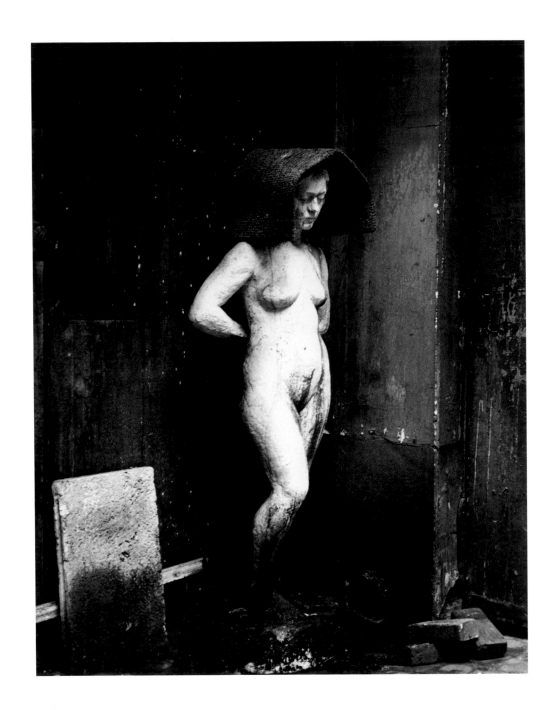

Abandonded Statue, Rue Jacob, Paris, 1948

Abandonded Statue, Paris, 1951

TODD WEBB:
An Appreciation

by Keith F. Davis

Charles Clayton Webb III was born in Detroit on September 15, 1905, the second son of Bertha Hollingshead Webb and Joseph Franklin Webb. His parents, both born and raised in Canada, had moved to Detroit at the turn of the century, and became naturalized U.S. citizens a few years after the birth of their second child. Joseph Webb had received a degree in pharmacy from the University of Toronto and worked as a druggist. The elder Webb son, Joseph Franklin Webb, Jr., was named for his father, while the second carried the name of his grandfather and great-grandfather. Very early in life, the younger child was nicknamed "Toddy", after a character in a book his mother had read, and the name — subsequently shortened to Todd — stuck.

As a child Todd was enthusiastic about sports and outdoor life. Although the Webbs did not have a strong interest in art, his mother enjoyed music and took the children to the art museum at least once a year. After spending his childhood in Detroit, Todd went to high school in his father's home town of Newmarket, Ontario, where he lived with his grandfather. The Webbs were strict Quakers and had become concerned when Todd attended a school dance without their permission. They decided that the smaller town of Newmarket would be a better influence on their son than Detroit had been.

A bright but largely unmotivated student, Todd graduated from high school in 1924 without clear career goals. An interest in writing had developed in high school, but he received little encouragement for his efforts. Attempts to write short stories continued for about a decade, but none were accepted for publication. Due to his seemingly more

practical skills in mathematics, Todd was encouraged to study engineering. He thus applied and was accepted into the School of Practical Science at the University of Toronto, where he spent about a year, in 1924-25.

Engineering did not hold his interest, however, and so the young man left to work in the excitement of the stock market. On discussing that aspect of his life, Webb laughs and calls it "ridiculous".[1] He knew nothing about the market, but the robust economy of the 1920s seemed to ensure unlimited growth. His firm specialized in underwriting new stock issues and, indeed, it seemed that everything they brought out went up. In the heat of such excitement all the employees — feeling they were in on the ground floor of great financial opportunities — overbought and overtraded, buying speculative issues on 10% margin or less. Webb made a considerable sum of money very quickly, and lost it even faster in the Crash of 1929.

After the collapse of the stock market, Webb became a gold miner in California. With the background provided by his courses in geology and mining engineering at the University of Toronto, Webb made, in his own words, "about fifty cents a day for the next three years." Working in arid country, he used a dry washer to separate gold flakes from sand and rocks. As the mined gravel was sent down an inclined chute, air was blown through it to carry away the lighter materials. Water was then used sparingly to pan gold from the remaining concentrate.

After his mining experiences, Webb stayed in California to work as a ranger for the Forest Service. He earned $125 a month plus board, but when the CCC camps were created in 1933 he went to the lower paying position of instruc-

tor, at $30 a month. With $1000 in savings he decided to go to San Francisco. He spent nearly a year there, writing and looking for work, before returning to Detroit.

In 1934 Webb began working for Chrysler. In 1937, when he had advanced to the Export division of the company, he was granted a leave of absence to travel to Central America. A friend from the Forest Service was prospecting for gold in Panama, and urged him to come down. His superiors at Chrysler let him go, thinking that the Spanish he would pick up would be useful later in his export career. Webb spent nine months in Central America, traveling and prospecting until his friend's bout with malaria ended the expedition. This trip marked a turning point, however, as it was the first time Webb had thought to bring a camera along on his travels. His Argus was unfortunately ruined when their dug-out canoe capsized in a storm, but the idea of photography began to take hold.

The 1930s saw a vogue for travel films or slide presentations of exotic lands narrated by intrepid travelers such as Richard Haliburton. Webb thought that such presentations might permit some creative expression of his interest in writing, as well as his beginning attempts at picture-taking. With his Panama experiences and these travelogues in mind, Webb bought a Kodak Special camera and began taking color slides. But it was black and white film — used to record a fishing trip — that made him think about still photography as a discipline in itself. "I got so interested in black and white that I gave up the travelogues and movies — everything."

A friend who belonged to the Chrysler Camera Club enlarged three of his black and white negatives, and the results won a prize at the group's next print contest. A short time later, during a two-week strike at the plant, Webb used the unexpected free time to hone his photographic skills. He bought an enlarger and, using the same three negatives, taught himself to print. Working day after day, he went through ten dollars of paper until he felt his prints were the equal of his friend's. By 1940 his interest prompted him to replace his roll film cameras with a new 5x7" Deardorff view camera. "I was hooked then, and I've never gone back to writing or anything else."

It was in the Chrysler Camera Club, which Webb joined in 1938, that he met fellow Chrysler employee Harry Callahan. The younger man shared Webb's enthusiasm for photography, and the two became close friends. Although

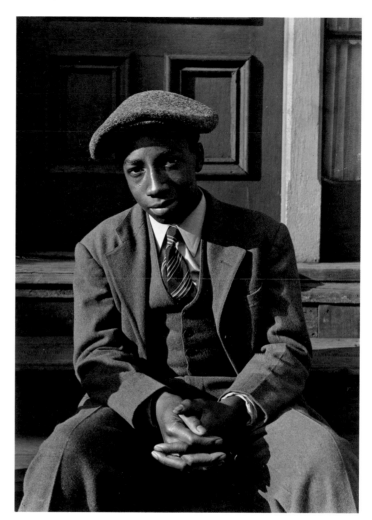

Detroit, 1942

the Camera Club provided an important outlet for their love of photography, neither Webb nor Callahan felt comfortable there. The predominantly Pictorialist emphasis on manipulated technique and anecdotal subjects contradicted their intuitive feeling for photography's potential. Webb recalls that the other 25 or 30 members seemed equally disinterested in the straightforward nature pic-

tures they made.

A new source of ideas was soon found in the person of Arthur Siegel, a Detroit-based commercial photographer and photojournalist.[2] Siegel had an extensive photographic library, many contacts among photographers, and a broad knowledge of photographic history. He also had been one of the first Americans to study with the noted European avant-garde artist and teacher Laszlo Moholy-Nagy, in 1937, at Moholy's nascent New Bauhaus in Chicago. In Webb's estimation Siegel was "way, way ahead of us at that time."

It was Siegel who organized Ansel Adams' visit in September, 1941, to the Detroit Photo Guild to lecture and give workshop demonstrations. Adams' ten-day stay was an intensive and inspiring experience for Webb. Adams led outdoor photographic sessions during the day and gave advice on darkroom technique at night. He showed his own photographs of Yosemite and the American West and talked about print quality, music, and Alfred Stieglitz. About thirty people participated in the workshop but, as Webb recalls, most seemed to resist Adams' views. Only a handful of participants, including Harry Callahan and himself, fully appreciated the noted photographer's message. But for this small group Adams' visit marked a turning point. "Ansel clarified everything and made what we were trying to do seem right."

After the Adams visit, Webb and Callahan worked passionately, seeking their respective photographic voices. In the following summer, Webb went to Rocky Mountain National Park, in Colorado, with Harry and Eleanor Callahan. Webb loved the mountains and photographed enthusiastically for nearly two weeks, rushing from one scenic view to another. On his return to Detroit his eagerness dropped precipitously as he processed a seemingly endless succession of beautiful — but dull — mountain negatives. In disgust he simply discarded the remaining unprocessed film. He had gone to Colorado because "I thought I had to photograph mountains in order to have any stature as a photographer." He returned knowing he had to make his own photographs, rather than those of Adams or anyone else, and that somehow his vision would embrace a world different from the majestic landscape of the West.

Spurred by his failure with things great and distant, Webb decided to focus on the small and familiar. For a

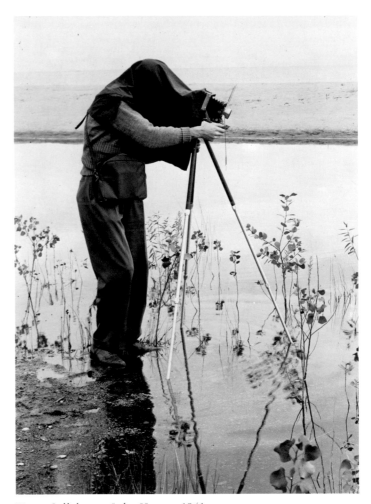

Harry Callahan at Lake Huron, 1941

month he photographed the details of his room, restricting himself to an intimately known setting to sharpen his seeing and increase his sensitivity to the photographic potential of the most ordinary subjects. This effort resulted in a group of about twenty-five prints, most of which were delicately geometric images of his ceiling (page 100). He realized that strong photographs depended not on the scale of his subject matter, but on his feeling of identity

Callahan's Hands, 1942

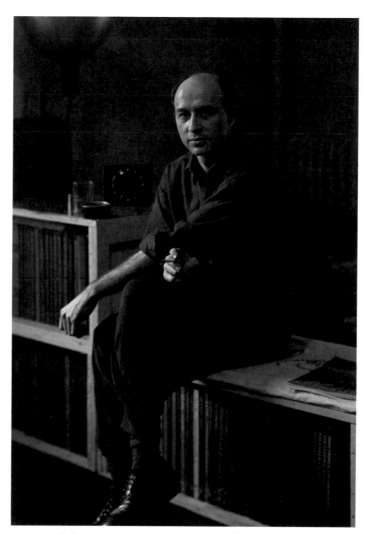

Harry Callahan, New York, November 1945

with his subjects and the quality and intensity of his vision.

Such experiments were cut short by the demands of the increasing American war effort. When Webb decided to join the Navy, he quit his job at Chrysler to make a quick trip to New York. Ansel Adams had suggested that Webb show his work to Dorothy Norman for possible publication in her journal *Twice a Year*. At that time Norman was based in Alfred Stieglitz's gallery *An American Place*, and Webb had a friendly and encouraging visit with the legendary master. Norman chose Webb's sensitive portrait of a young man in a suit and cap for publication (page 95).

Because Webb had to rush off to basic training, Harry Callahan graciously agreed to print a thousand original 5x7" contact prints that were mailed to Norman and hand-tipped into the copies of *Twice a Year*.

After boot camp, Webb was shipped to the Pacific in April, 1943 as a Seaman, Second Class. By assisting a pro-

fessional photographer — who, as a studio portraitist in peace time, knew little about outdoor work — Webb got back into photography and earned a rating of Photographer's Mate, Second Class. During the next thirty months he was attached to the Seventh Fleet, stationed in New Guinea, the Philippines, and smaller islands in the South Pacific. He worked on a variety of assignments as needed and particularly enjoyed those with the Seabees, who "could build a dandy darkroom — those guys could build anything." He was ashore most of the time, and saw relatively little heavy combat.

In his free time Webb made portraits of the natives in the jungles of New Guinea and the Philippines. "He found the natives friendly and appreciative of sympathetic attention; he made trips with them into the back country, photographing them, listening to their music, and learning some of their language."[3] These images were processed in the field and carefully compiled in albums. The isolation and simplicity of the natives, and the beauty of their benign environment must have contrasted markedly with the brutality of the war going on over the horizon. And all the while Webb was "dreaming of New York and hating the thought of going back to Detroit to work in an automobile factory."[4]

Webb returned to the U.S. on leave in July, 1945 and, with the sudden end of the war in early August, was sent to Rhode Island to await discharge. At about the same time, Harry Callahan had taken a leave from his job in Detroit and moved to New York City, determined to stimulate his growth as a photographer by way of a "personal fellowship". Webb commuted nearly every weekend from Rhode Island to visit the Callahans in New York. When his discharge finally came in November, 1945, Webb expected to return directly to Detroit to reclaim his old job, but the Callahans encouraged him to stay with them for a short time. Looking forward to using his 5x7" camera once again — which Callahan had held for him during the war — Webb moved to New York for what he thought would be a brief stay. A small darkroom was constructed in the apartment's Murphy bed closet, and Webb became so excited about photographing the city that he decided not to reclaim his old job. When the Callahans moved back to Detroit in early 1946 he found himself alone in the city, eager to photograph.

For Webb, New York was an overwhelming experience. The city represented the greatest concentration of human achievement, energy, and diversity he had ever seen. He was stimulated by the sights, sounds, and smells of the urban environment, the people he came to know, and the challenge of accomplishing his personal work while beginning to earn a living in the competitive professional arena.

Webb recorded his wide-eyed enthusiasm for the city and its amazing panorama of humanity in his daily journal.

Photographed with some feeling for the first time in a week — the weather was nice and I felt full of the streets and the people...I did some kids playing a game — real wonderful kids — colored and white. I am sure that the kids had no feeling of any difference between them because of their color. I had the same feeling myself — of no difference...[5]

On Mulberry St. and on Mott St. north of Chinatown the streets are literally teeming. They are "pushcart" streets — besides the endless rows of small stores, business is done from pushcarts in the street — fruits and vegetables, neckties, dishes, fish, clothing and everything under the sun. The smells and the noise and the whole feel of the place...just isn't describable.[6]

I photographed down on the lower east side today and it was quite exciting — that is a very potent section of the city. The buildings are old and they wear the years with an air. The layer on layer of paint on the storefronts give them a nice "lived in" feeling. The people are mostly poor, I think, but somehow they seem to have a dignity that you don't expect to find with poverty — even the kids seem to be proud. There seem to be small sections — just a couple of streets maybe, where different nationalities live. I saw little groups of Spanish stores, Greek coffee houses, Italian and Polish shopping centers. It's America — you see more American flags displayed down there than anywhere else I know of. They sent a lot of boys to war as evidenced by the Honor Rolls that each neighborhood displays — lots of gold stars on them too. I think of the boys that I knew in the ser-

vice that were from New York — I understand them better now.[7]

Late in the afternoon I went on a sight seeing trip sans camera. I took the 125th St. Ferry to New Jersey and walked on down to the 42nd St. Ferry. Seeing Manhattan from across the river was really something. I couldn't help but think of the old saw, "fabled city" — it did seem almost too big to be true. From midtown the apartment houses on Riverside Drive seem to stretch endlessly north — they must house a million people. The activity on the river — the car ferries — the tugs — the big ships — it all makes you understand how the great city lives. Yes, I want to photograph what I saw yesterday — it has been done a million times but I had a strong feeling for it — it was so exciting and if I can show a little of what I felt they won't be corny.[8]

I went to Coney Island and the beautiful, beautiful people were so wonderful. The feeling was so strong that sometimes tears actually came to my eyes — I don't know why — people were just trying so hard to have a good time that it hurt...What a thing — a million people taking their hair down — hicks for a day — all of the county fairs in the country in one place and every Sunday — the wonderful expressions — the people just arrived — all eyes, rarin' to go — the people ready to go home — hot, sticky and just plain tired — bored, disappointed, sunburned, stomachs tortured by too many hotdogs, pop, corn on the cob, frozen dessert — "God, I am never going to come here again — maybe".[9]

I never fail to be thrilled and amazed by the view of Manhattan from a high place. I have a great feeling of pride in my city — where else in the world could you see such a sight. It is fantastic — it is so American — I feel a close relationship between this city and the restless and ingenious people who settled the West in the early days.[10]

He recorded some of the memorable people he met and photographed:

One of the photographs that I made yesterday has a beautiful quality — ortho film — it is of four young boys who happened to come along as I was setting up to take a store front down on South St. near the Fulton Market [page 47]. They were tough young eastside kids but nice and quite understanding. They wanted to have their picture taken and it seemed that they might fit into what I was doing so I told them to stand in front of the window. They stood up in a row and I asked if they wouldn't stand just as if they had been talking. The leader, in what I called the best Brooklynese said, "Oh, you mean nonchalant. O.K. guys get nonchalant." It sounded much funnier than it reads.[11]

On the lower Bowery I saw an amazing woman...plastered with paint. A guy on the bum insisted that I take her picture [page 46]. It turned out that she was Masie "Queen of the Bowery" and the gag was that the bum wanted me to take a picture of her giving him a dime. She walks along the Bowery giving out dimes to all of the down and outers. It is really funny the way all of the boys greet her with a big "Hello Masie" and sidle up to her to get their dime.[12]

Within months of his arrival in New York, Webb came to know a number of the major figures in the art and photographic scene at that time, including Alfred Stieglitz, Georgia O'Keeffe, Berenice Abbott, and Lisette Model. At Abbott's suggestion he attended a meeting of the Photo-League, where he was introduced to Morris Engel and Aaron Siskind. Beaumont and Nancy Newhall became good friends and through them he met Minor White, Andre Kertesz, Helen Levitt, Barbara Morgan, Charles Sheeler, Henri Cartier-Bresson, and the writer Ferd Reyher. Through Reyher he met actor Peter Lorre and playwright Bertolt Brecht. Later he met and worked with Walker Evans and Roy Stryker,[13] and began a productive friendship with Edward Steichen, the Curator of Photography at the Museum of Modern Art.

The most profound personal influence on Webb was probably his friendship with Alfred Stieglitz, whom he visited frequently until the older photographer's death on July 13, 1946. They ate ice cream and talked about a wide

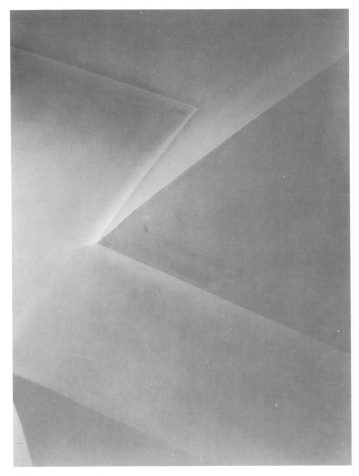

Ceiling of My House, Detroit, 1942

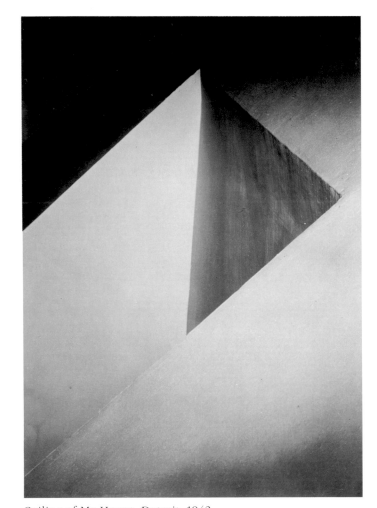

Ceiling of My House, Detroit, 1942

variety of topics, including Stieglitz's early life in Berlin, sports, the evolution of Georgia O'Keeffe's work, the paintings of Arthur Dove, John Marin and Marsden Hartley, and the photographs of Edward Weston, Edward Steichen and Eugene Atget. Stieglitz showed his own photographs sparingly, but with great effect, while the younger photographer often brought his own work for comment.

It has been a real privilege for me to know Stieglitz — I feel very close to him when we are sitting in the office talking — and I feel very close to the real values of life as I wish to live. He has no isms — no politics — no formulas for living. One of the things I love most about him is his fairness — many times I have heard him say beautiful things about people I am sure he doesn't have much use for. He does not, for personal reasons, deny them the credit which he feels is due.[14]

Despite his consistent optimism and good friends, Webb's life in 1946 was, by middle class standards, precarious. Film was hard to get, money was tight, and he agonized over turning down the security of his old job in Detroit for the freedom to photograph as he wished. The importance of this sacrifice magnified the frustration he felt on unproductive days. Soon after his one-man show at the Museum of the City of New York had been arranged, Webb wrote in exasperation:

I am in a hell of a slump right now photographically. I am not seeing and can't even seem to get a decent negative. It is depressing but I think it is something that you have to put up with once in a while. I feel that maybe having that show has something to do with it — I am human enough that it sort of impressed me with my own importance. I start seeing myself as "Webb, the great documentarist" — I start looking for things to photograph that will fit that category and I am lost. I don't look consciously but I have a stinking suspicion that is the trouble.[15]

Inevitably, however, such doubts and financial concerns were more than balanced by Webb's optimism and commitment to photography.

My photography is the purest thing that I have ever done — it is real and true and the fact that it doesn't pay off in money is not important to me.[16]

On the first anniversary of his discharge from the Navy he wrote:

What a year — I feel that there has been a great development in me — I can feel it meeting people — I have a confidence I lacked before — I am somebody — I have a contribution to make and I am making it in my simple way. The scope of my work and seeing is greatly enlarged — I can photograph anywhere now...

With self-deprecating humor he continued:

The day really called for some sort of celebration but in the typical Webb way I had forty cents left af-ter the weekend and found that there was a Bank Holiday. After a nickel downtown and a nickel back — a nickel for a paper — a nickel to call Ferd and a package of cigarettes — now I have a cent. Luckily I had plenty of food in the house...[17]

While Webb's assignments for *Fortune* and Standard Oil initially caused him concern over their effect on his personal work, he felt considerable relief in earning a living with his craft. And happily, his peripatetic nature was well suited to the needs of his employers. In 1947-48 Webb traveled extensively throughout the eastern half of the United States, photographing as far west as Oklahoma. Earlier, in 1946, he had considered a job in Alaska, largely on the basis of its sense of distance and adventure. In 1948, he eagerly accepted an assignment to photograph in Britain.

After completing his series of color photographs of the English countryside, Webb planned a quick trip to Paris before returning to New York. While the beauty of Paris had been impressed on him by friends and the photographs of Eugene Atget, the city itself surpassed his already high expectations. Paris was an overwhelming visual experience, every bit as thrilling as his first sustained encounter with New York. On the day of his arrival he noted:

It is silly to say that I am nuts about Paris, but I am...with the light I had today it is a photographer's dream.[18]

After a two-week visit in September, 1948, Webb packed his things in New York and returned to Paris in February, 1949 for an indefinite stay. Webb was immediately caught up in the vitality of his new surroundings and made many friends. He renewed acquaintances from New York with photographers Fenno Jacobs, Gordon Parks, and sculptor Mary Callery and met Louis Stettner, Brassai, Robert Capa, and others. As always money was tight.

...the weather continues beautiful beyond description. And I continue to be broke in the same way...[19]

But with his contacts and increased confidence, professional assignments materialized, allowing him to survive

with a modest income and high spirits.

This is the good life. Made 8 big negatives [8x10"] today and have them developed and printed tonight. That is like the old days in New York...When I am in a foreign country I want to squeeze the last drop out of it — I want to learn and understand as much as possible about it...Now I am working and I feel pretty cocky — What is there in it for me? I don't know — certainly not material wealth — but whatever it is I accept it humbly and with thankfulness. I guess it is just really full living — but life has nothing more to offer any man. Maybe I have something — maybe I am really rich.[20]

A deeper understanding of Webb's photographs of this period should begin with a review of what was written about them by a leading critic and the artist himself. The finest contemporary appraisal of Webb's New York work was written by Beaumont Newhall. An early friend and supporter, Newhall had helped arrange Webb's first exhibition, "I See A City", at the Museum of the City of New York. This exhibit included 160 prints, all made since his arrival in the city the previous November, and ran from September 24 to November 3, 1946. Newhall wrote an insightful paragraph for the show's press release:

Todd Webb came to New York from the Pacific with a strong desire to discover the city with his camera, and the result is a series of superb photographs. He has seen our city not as a glittering megalopolis, but as a community. He has chosen to focus mainly upon Third Avenue and those blocks where the shops are small and living quarters crowded. He works with swift precision, directly and honestly recording what he sees. His straightforward, unmanipulated contact prints convey a maximum sense of authenticity and are historical records of obvious documentary value. More than this: they are personal interpretations, through which he has imparted to us warmth of appreciation and the excitement of visual discovery. He brings out the human quality even when people are absent. His prints are brilliant. In them we feel the presence of light, re-

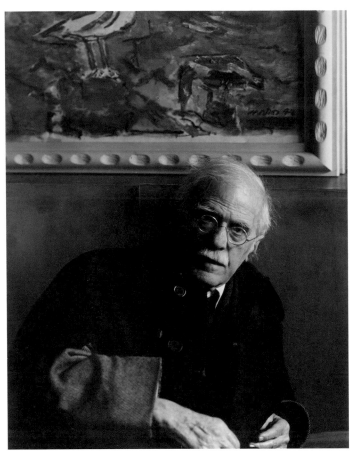

Alfred Stieglitz at *An American Place*, New York City, March 19, 1946

vealing the texture of wood, brick and weathered paint, the homely designs of shop fronts, paintings on window glass and Welcome Home GI Joe signs. Detail plays its part without protruding; delight in the photogenic is balanced by a feeling for people; composition does not become the obvious pattern shot. Above all Todd Webb's portrait of the city is dignified. It is revealing, it is not always pleasant, but it is a portrait which all New Yorkers will respect and appreciate.[21]

In an *Artnews* profile entitled ''City Lens'', published to coincide with the exhibit, Newhall expanded his comments on Webb's work.

Like all of us who were overseas, Todd Webb made Utopian post-war plans. He was going to spend a year photographing New York. Unlike most of us, he carried out his dream. Although the year is not yet up, his photographic discovery of New York has been so intense and moving that 160 of his prints now hang in his first one man exhibition, ''I See a City'', at the Museum of the City of New York.

It is not easy to photograph a city so that its special character is revealed. It is a great temptation to concentrate on the spectacular architecture. Yet people make the city what it is, and the physical fabric is of significance only as it reveals their lives and aspirations.

Todd found the most intense record of the people in those streets where living conditions are crowded and small shops abound. He found that the strange calligraphy of the city — wall scrawls of children and flamboyant painted fish on plate-glass windows — showed the character of the dwellers. He photographed ''Welcome Home GI Joe'' decorations on apartment doors as tenderly as if he saw his own name lettered on the crude and colorful signs. Signs of all kinds were photographed not only for what they said, but more especially for their style. He made one series of humble, religious meeting places, churches behind shop-fronts and in basements, marked off from neighboring doorways by symbols as naive as those of the early Christians. Third Avenue he found a most fruitful area: the elevated structure casting strange patterns on the cobblestoned street, weird architecture of stations, views from station platforms. He particularly liked shop-fronts, and doorways opening into dark mysterious depths in which the detail of a staircase can barely be seen.

During the first few months of what Todd has called his ''personal Guggenheim'' he worked with a 5x7 inch view camera, the classic stand camera, almost identical to what Eugene Atget used in Paris in the early years of this century. As he became more fa-

miliar with the city, people began to appear in his photographs. The presence of people is felt in Todd's work, even when no human image is visible...[22]

The show's press release also contained an artist's statement in which Webb acknowledged some of those who had helped and influenced him, and gave a few details on his technique.

This exhibition, I know, is just a small beginning — it represents the work of just a few months. I feel strongly the influence of my teachers, Art Siegel and Ansel Adams — of photographers, Stieglitz, Walker Evans, Helen Levitt and many others. The encouragement that I received from Dorothy Norman, Stieglitz, Nancy and Beaumont Newhall and many others must also be given credit — without it I would no doubt have returned to my old job in Detroit months ago.

All of the early photographs in this exhibition are contact prints made with a 5x7 Deardorff camera. I had three lenses, a 6½, a 9½ and a 12 inch. Some of the things made during June, July and August were made with a 4x5 Speed Graphic — some with an 8x10 Deardorff.

I would like to have used Isapan Film for all of the negatives but due to the shortages I had to use whatever was available. The negatives were all developed in ABC Pyro and the prints were made on Azo paper developed in Amidol.

I have no theories about photography or life or anything else. So I am really free to follow my passion, photography.

Webb's initial reluctance to comment on his work was largely overcome by 1954, when he wrote a particularly direct statement on his approach to photography.

Our time, recorded by individuals from all walks of life, will probably be one of the most complete visual documents to date. There are many different and legitimate approaches to the same subject matter. To me, photography is the opportunity to express what I feel about our time. The small abstrac-

tions — usual daily happenings, objects, places, day-by-day incidents of living — isolated and interpreted by the seer as he records with the camera are important. They are important because they are the often overlooked, the usual rather than the sensational and the dramatic. For me, the commonplace in its constancy of occurrence is the dramatic. It is the major portion of our lives. The great dramatic instances are the 'now and then' of living which tend to overshadow the basic design and texture of our every day. I seldom photograph accidents, human or otherwise. I have an intense interest in and feeling for people. And often I find subject matter with no visible persons to be more peopled than a crowded street scene. Every window, doorway, street, building, every mark on a wall, every sign, has a human connotation. All are signs and symbols of people — a way of life — living in our time.[23]

As excerpted above, Newhall's commentary and Webb's own statements suggest a set of characteristic themes which include the artistic value of the commonplace, the richness of human realities and communal bonds, the integrity of honest, unmanipulated vision, and the need to work intuitively. Such concepts are central to a deeper understanding of both the uniqueness of Webb's work and its relation to the photographic currents of his time. The lineage of some of these ideas may be suggested in the following brief outline of the conceptual climate in which Webb worked.

Webb's work stems from an era in which a faith in visible reality was newly important — an era motivated in a variety of ways by documentary concerns and the perception of a human resonance in the physical world. This sensibility begins with the basic act of perception. Alfred Stieglitz felt that "the basis for all that is meaningful in life is man's capacity to see the objective world."[24] And Walker Evans similarly believed in

a new way of seeing where all objects, including language, had simple integrity and truth and where the artist's task, rather than finding form or giving shape to imagined things, was to rearrange that which already existed.[25]

After a visit to Abbott's studio, Webb noted in his diary that *"there were a bunch of Atgets laying on the table in Berenice's studio — almost all of trees — a revelation to me — and so refreshing — honest to God seeing — no pretense, no fake, no axe to grind."*[26]

This objective vision, focused on the details of contemporary life, provided the basis for a broadly humanistic expressive sensibility. This approach perceived the physical world as rich with the traces of humanity, and believed that such evidence could, in important ways, reveal the larger significance of time and man. In her book *A Guide to Better Photography* (1941) Berenice Abbott quoted from Balzac's 1831 essay "The Quest for the Absolute":

It so happens that human life in all its aspects, wide or narrow, is so intimately connected with architecture, that with a certain amount of observation we can usually reconstruct a bygone society from the remains of its public monuments. From relics of household stuff, we can imagine its owners 'in their habits as they lived.'[27]

In 1948 Ferdinand Reyher wrote that Atget "photographed not the buildings but the nature of building, and the materials of building — stone, wood, iron, work, lives..."[28]

In an essay on the influence of Walker Evans, Alan Trachtenberg noted that photographers to the present have shared the conviction that "nothing is more rich with human meaning than the commonplace, and that photography is an unrivaled instrument for grasping the fleeting vibrations of life where people assemble and leave their marks."[29] Many of these artists, like Berenice Abbott, have felt that "the potentiality of the camera for communication of content is almost unlimited. The photographer, full of detail and objective, visual facts, speaks to all people."[30]

This notion of the objectivity and universality of the documentary mode, and in particular of photographic documentation, was characteristic of larger cultural and political forces in the New Deal era. William Stott notes that in the 1930s

a documentary motive was at work throughout the culture of the time: in the rhetoric of the New Deal

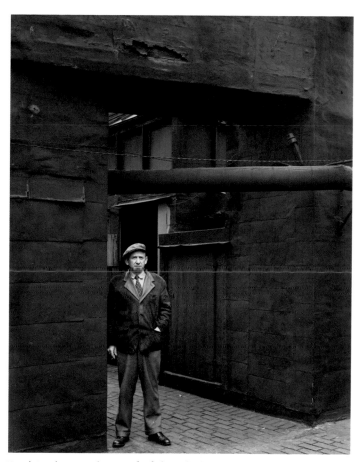

Ferd Reyher on the Roof of the Chelsea Hotel, New York, 1946

a sense of progress to a feeling for the past and what was being lost, a faith in architecture and artifacts as evidence of humanity, and the centrality of people to larger economic and cultural issues.[33]

Underlying this documentary motive was the sustaining idea that it was active, affirmative and empathetic. It respected the "blazing fact of the matter" while transcending a passive collection of data.[34] Beaumont Newhall, in *The History of Photography* (1949) stressed the "historical, realistic [and] factual" foundation of documentary while noting the essential "desire to create active interpretations of the world in which we live" which separated "documentary photography at its best [from] bald camera records."[35] The aim of documentary work at this time was to make it "possible to see, know, and feel the details of life, to feel oneself part of some other's experience."[36] By extension, it was hoped that such investigation would provide the "information necessary to organized and harmonious living" through the identification and rational solution of social ills.[37]

In its myriad expressions this basic documentary idea reflected a new historical and political attitude. This new sensibility was characterized by an awareness of the rapidity of cultural change and the passing of familiar ways of life; the need for an "authentic" American vision shaped, in part, by rugged individualism and the Pioneer Spirit; the celebration of the common man over the rich and powerful; and a desire for the wholeness of communal bonds.

Artists of the period had a keen sense of the relationship of past and present. William Carlos Williams felt the poet's imagination "to be a mental kaleidoscope consisting of old and new images, whole objects, and fragments of last year's as well as yesterday's experiences."[38] Berenice Abbott's photographs of New York in the 1930s were motivated by her "fantastic passion" to picture the effects of change in the dynamic city. Abbott sought to "determine the objective historical forces at work in contemporary life" and to portray these forces "through their manifestations in material forms."[39] Similarly, many of Walker Evans' photographs reveal the "effects of time and change on the man-made products of America's early industrial period."[40] Even Stieglitz's very personal photographs of New York in the 1930s focus on physical change and the construction of new buildings.[41] And Ferdinand Reyher

and the WPA art projects; in painting, dance, fiction and theater; in the new media of radio and picture magazines; in popular thought, education and advertising.[31]

F.D.R. himself "had a documentary imagination: he grasped a social reality best through the details of a particular case."[32] In magazines such as *Fortune*, photographs were consistently used to evoke the feeling of people and man-made places. *Fortune's* photo-essays objectified a larger set of pictorial ideas which included the linkage of

noted Atget's deep interest in the way objects asserted "their form and function against the grinding of time, the gnawing of weather, the tug of gravity and the hand of man."[42]

Stieglitz, Abbott, Evans, and others consciously turned their sense of history to the task of creating an authentic American art. While a young man attending school in Germany, Stieglitz had a "glorious vision of America, inspired by his history books."[43] On his return to America in 1890 he sought to regain "contact" with his country by exploring the bustling streets of Manhattan. Stieglitz felt that through an intimate sense of place one could gain a larger awareness of the energy and potential of the nation itself. Through Stieglitz's influence a number of important artists began, after the Armory Show in 1913, "to use their newly discovered methods of visual notation to explore and define the content of the American Scene."[44] Walker Evans, for example, sought an "indigenous American expression [in the] physiognomy of a nation".[45] The search for a native American expression became a particularly central artistic endeavor following the destruction and demoralization of Europe in the First World War.

One aspect of this celebration of America was the use of the Pioneer motif as a metaphor for the individualism, courage and constructive energy needed by the artist. The Pioneer Spirit symbolized a golden age of adventure and potential that was recreated by many artists as personal myth. The notion of the "Pioneer Spirit" touches on or subsumes the related ideas of the pastoral ideal; the mythic quest and rites of passage; innocence, cleansing, and rebirth; and the potentials of a New World. These latter ideas are central to James Agee's observation that Helen Levitt's photographs of the 1940s are about "innocence — not as the word has come to be misunderstood and debased, but in its full, original wildness...",[46] and to Ansel Adams' "A Personal Credo" from 1944:

Documentation — in the present social interpretation of the term — will burst into full flower at the moment of peace. Herein lies the magnificent opportunity of all photographic history. Here is where the camera can be related to a vast constructive function: the revelation of a new world as it is born and grows into maturity.[47]

It is significant in this context to cite the opening paragraphs of Webb's introduction to his book *The Gold Rush Trail*, written in the late 1950s after his Guggenheim travels through the American West.

This volume is the result of a lifelong love affair with the immigrant trails of the American pioneers. It was motivated too by a feeling of having been excluded from participation in a dramatic period of our history by not having been born until long after that era came to a close...

In my early boyhood, my grandfather delighted me with tales about *his* grandfather's wagon train journey in 1806 from eastern Pennsylvania to Ontario, Canada...

During my teens the westward expansion of the nineteenth century America caught my interest. As I pored over the historical volumes, the fur traders, the land-hungry settlers, the gold-seeking 49ers and the empire-building railroaders became my heroes, and a longing to emulate their adventures was born. Later I partially satisfied this longing by taking several long canoe trips through the Canadian wilderness, by working as a forest ranger in California, and by prospecting for gold in the Southwestern states and Central America. I was a frontiersman at heart but with no frontiers to conquer...[48]

The Pioneer Spirit symbolized the accomplishments of large numbers of unsung heroes working together with courage, imagination and stamina to create a new world. Similarly, the artists of Webb's era were characterized by a Whitmanesque sympathy for the common man and everyday life. In contrast to the false values of competition, accumulation and power, the common man was seen as the repository of genuine emotion, natural creativity and basic goodness. James Agee noted that Helen Levitt's subjects were largely the poor and children, among whom "there is more spontaneity, more grace, than among human beings of any other kind."[49] And Lincoln Kirstein perceived that Walker Evans' photographs concerned themselves with "the vulgarization which inevitably results from the widespread multiplication of goods and services, and the naive creative spirit, imperishable and inherent in the ordinary man."[50]

106

This idea of identity with the common man was one expression of a larger utopian longing for a cultural and personal wholeness. The Stieglitz circle typified these ideas with a philosophical emphasis on the underlying unity of all things. Earlier, Whitman had perceived New York as an ensemble, a whole. All the sights, sounds, and people of the city contributed to the greatness of the totality: "Great or small, you furnish your parts toward the soul."[51] Likewise, Helen Levitt's pictured world "stands for much more than itself...it is, in fact, a whole and round image of existence."[52] And, in Evans' work a single street, house or face seems to symbolize the "terrible cumulative force of thousands of faces, houses and streets."[53]

In the post-war period a distinct shift occurred in the nature of this artistic quest for wholeness. An earlier celebration of cultural unity within diversity gave way to an "intense, fervid quest for wholeness" manifesting itself as a "desire to link oneself to a historical tradition."[54] The earlier impulse toward a total, unifying vision of America becomes "embattled in the postwar period" as it is replaced by the fragmented visions of minority and personal perceptions.[55] The notion of unity was frequently displaced into an idealized past, "a fictional place of pastoral refreshment for Americans who lived in a society increasingly technological, grand, and anonymous."[56] This past could be the relatively distant era of the Pioneers, or it could reflect a surprisingly recent America. A literary critic has noted that the Cold War saw a "nostalgia for the simpler political and historical patterns of World War II, when everyone worked together with a common purpose."[57] In both cases the past — whether of the 1840s or the early 1940s — seemed to provide a unity and cultural consensus that was felt to be lacking in the post-war era.

The image of the modern city reflects these shifting attitudes. As a complex mirror of the human mind, the city's intensity and opportunities have historically been balanced by its manifestations of the problems of alienation, impersonality, and the breakdown of communal and spiritual bonds. In modern times the city has come increasingly to be perceived as a symbol of social and psychic fragmentation rather than as an ideal of unity within racial, economic and cultural diversity. Images of the city seemed increasingly to focus on the alienation and exhaustion of its inhabitants, and to thereby discredit earlier, positive notions of universal humanity. For some art-

ists and thinkers the small community became the only plausible artistic symbol of social cohesion; for others the largest measure of human unity became the solitary self.

Given the perceived mechanization and insensitivity of the dominant culture, it is not surprising that another important component of Webb's artistic climate was its emphasis on intuition, sincerity and feelings. Americans have always distrusted theorization and intellectualism. Indeed, "a strong suspicion runs through modern culture in America that ideas, insofar as they take the form of abstract thought, represent a threat to the wholeness of life, to the interplay between mind and emotion necessary for a healthy existence and a vital art."[58] Stieglitz felt that intellectualism was "ultimately a hindrance to the artist who wished to express the essence of things."[59] He wrote that

When I am no longer thinking, but simply *am*, then I may be said to be truly affirming life. Not to *know*, but to let exist what is, that alone, perhaps, is truly to know.[60]

In his essay on Atget, Reyher praised the legendary photographer as "the old one who never expressed a theory."[61] Similarly, James Agee noted that "like most good artists, Miss Levitt is no intellectual and no theorist",[62] while, for Walker Evans, a photographer was "a sensualist whose eye 'traffics in feelings, not in thoughts.'"[63]

Feelings thus represented something basic and true in a modern world that seemed increasingly characterized by duplicity, cut-throat competition, and insensitivity. By emphasizing their own ability to feel, and to articulate feeling in symbolic form, artists offered the means for the larger society to create itself anew. From this perspective, all things could become symbols of the sensitive seer's feelings. In his 1946 article "An Adventure in Photography" Harry Callahan noted that "these pictures of weeds in the snow are desired to express feeling more than anything else...."[64] And Ansel Adams stressed

the sincerity of intention and honesty of spirit of the photographer....What is required is an underlying *ethic* and sensitivity to the important and true qualities of the world in which we live...A great photograph is a full expression of what one feels about what is being photographed in the deepest sense,

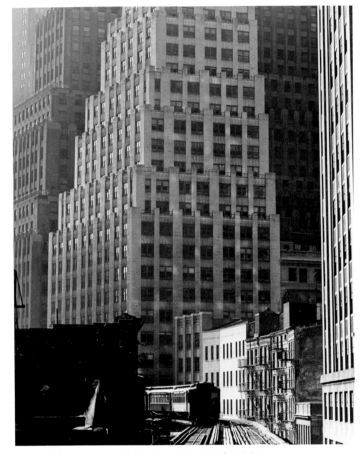

From Fulton Street El Station, New York, 1948

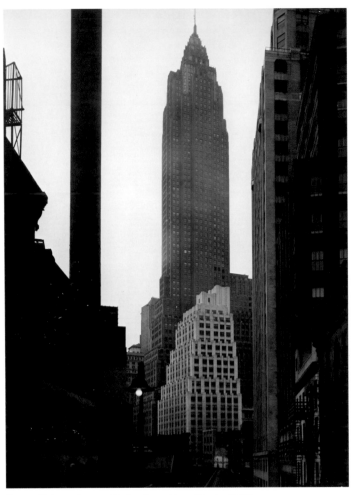

From Fulton Street El Station, New York, 1946

and is, thereby, a true expression of what one feels about life in its entirety.[65]

This deep feeling toward one's subjects was expressed often as tenderness and love: signs of vulnerability and humanity in a cold and ambitious world.

It was not mechanization or business as such that [Stieglitz] protested against. It was the sacrificing of the living spark, of the element of deep caring, of love...One might say that Stieglitz fell in love with that which represented caring or love in their simplest terms.[66]

Arthur Siegel wrote on Atget in similar terms:

Essentially a romantic, he photographed Paris with the single-mindedness of a man in love... Here are lyrical images, peaceful pictures. A man examining

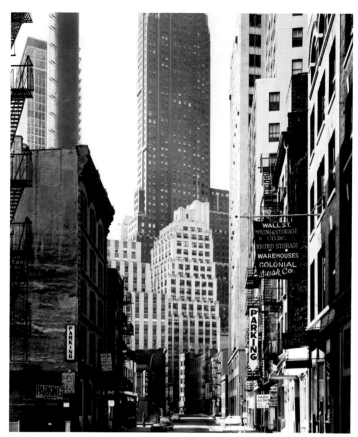

Pearl Street, South from Fulton Street. Site of the old Fulton Street Station on the Third Avenue El, New York, 1959

cated none of them. In important ways, his pictures are more earthly than Stieglitz's, warmer than Abbott's, more intuitive than Evans' and more literal than Callahan's. When he began his New York work, Webb was already forty years old, with a variety of experiences behind him. As with all important artists, Webb's work is both a product of his time — illuminating certain common currents of artistic thought — and the tangible record of a unique sensibility in contact with corporal reality. Webb shared certain guiding ideals with other artists of his era, but his expression of those concepts was entirely his own.

The "Welcome Home" signs (pages 16-19) were among the first subjects Webb photographed in New York. These warm evocations of home and community speak eloquently of the desire for normalcy after the disruptions of the war. In Webb's photographs we see no parades, brass bands, or tear-stained faces. Instead, we are encouraged to ponder these signs as still, proud emblems of service and community. The signs indicate the soldier's place in a multi-leveled system of obligation to nation, neighborhood and family. These levels are mutually reinforcing and describe the linkage between our ideals of citizenship, friendship and kinship.

Each of these signs identifies a home place, while it emphasizes the doorway as the juncture between the public world of the street and the private realm of the family. In his gentle, respectful way, Webb does not lay claim to a false intimacy with these individuals or homes; his vision is that of an acutely perceptive passerby sensitive to the difference between these two realms.

The clarity and rectitude of Webb's vision emphasizes the uniqueness of each sign and home while, at the same time, suggesting a larger system of common values. Webb photographs signs that evoke, in the simplest terms, the emotions and bonds fundamental to the basic fabric of society. In these pictures the signs themselves become gentle objects of wonder with the power to convey the specific and the universal, history and timelessness, and the simple and the profound. These images recall W.H. Auden's belief that "the House is more than personal: it is an outpost and repository of civilization",[69] and Gaston Bachelard's observation on

with tenderness and understanding the symbols of a fast vanishing 19th century.[67]

And in his diary Webb noted:

As Stieglitz and Ferd have both said, my work has a tenderness without sentimentality. It is hard for me to hate — even the decadent rich — life having been so good to me...[68]

While Webb's photographs were influenced, directly or indirectly, by many of these ideas and artists, they dupli-

how concrete everything becomes in the world of the spirit when an object, a mere door, can give images of hesitation, temptation, desire, security, welcome and respect. If one were to give an account of all the doors one has closed and opened, of all the doors one would like to re-open, one would have to tell the story of one's entire life.[70]

The simple storefront churches (pages 20-25) drew Webb's attention for similar reasons. Such churches represented small kinships of faith providing a structure of meaning for their members. And, by inhabiting old retail spaces, these tiny houses of worship quite literally represented the replacement of commercial values with those of the spirit. Webb loved the simplicity of these structures and the heartfelt directness of their painted and lettered signs.

Like the "Welcome Home" doorways, these church facades function as membranes between two worlds: the private, communal realm of passion and faith, and the public world of secular, commercial values. The planar, graphic boldness of Webb's images and the opacity of the facades themselves combine, once again, to withhold easy access into the lives of others, while suggesting the universality of those lives.

The importance of these churches is suggested in James Baldwin's powerful and eloquent novel *Go Tell It On The Mountain* (1953). Through the eyes and feelings of his young central character, John, Baldwin evokes the impassioned life of these structures, and their function as places of contemplation and retreat from the public world of the street. John's church, emblazoned with the name "TEMPLE OF THE FIRE BAPTIZED" stood on the corner of a "sinful avenue". It had been rented, repaired and painted by "the saints" and now contained a pulpit, piano, camp chairs, and "the biggest Bible they could find." As John stands alone in the empty church, the sounds of children playing and adults cursing drift in from the street. "The darkness and silence of the church pressed on him, cold as judgment , and the voices crying from the window might have been crying from another world."[71] These photographs of church fronts suggest complex messages of poverty and transcendence, the temporary and the eternal, freedom and necessity. They are about the glowing passions of faith and the decay and contingencies of the

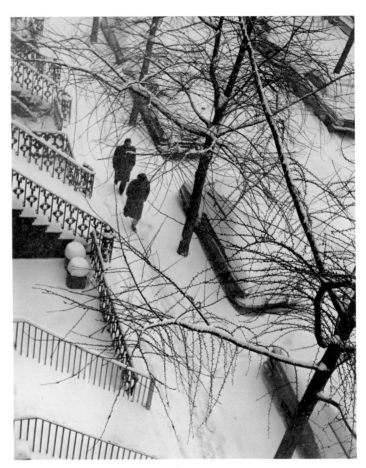

St. Luke's Place, New York, 1960

material world.

Webb's images of New York combine a sense of context with an incisive eye for revealing details. His "Lower Manhattan from Brooklyn Bridge" (page 26) reveals a "bird's-eye" view of the relationships between warehouses, older buildings and soaring skyscrapers, in which a progression through time is suggested by a movement from the horizontal to the vertical. Similarly, his photograph of the Manhattan Bridge (page 27) portrays several levels of experience: from the intimate world of children playing to-

gether on a doorstep, through the slow daily cycles of a quiet neighborhood, to the looming background bridge, a major conduit for traffic and commerce into the busy island.

An abiding sense of history — of the passing of time — infuses many of Webb's city images. He records both the survival of older things and the visible process of change. His view of "Peck's Slip" (page 29) records old, half-empty structures on a cobblestoned street near the wharfs. In "Slum Clearance" (page 31) his focus on doors and passageways suggests the intimacy of private spaces now stripped of their human aura. His views of the Third Avenue El (pages 8, 33) describe the beautiful patterns of light and shadow on stone while celebrating a disappearing aspect of city life. In "Third Avenue" (page 33) Webb combines the rhythmic shadows of the El and the recession of the tracks in space with a gentle meditation on various eras of transportation. In this image we see a seemingly 19th century horse-drawn cart, the soon-to-vanish El, and the now-ubiquitous automobile. Webb was fascinated by the evidence of such overlaps between historical or technological epochs.

This historical sensibility is clear in the three images reproduced on pages 108-109. In visits to this site in 1946 and 1948, Webb made very different photographs of the view looking south along the 3rd Avenue El tracks from the Fulton Street Station. In 1959, after the El had been torn down, he made yet another photograph from the same spot — this time from ground level — to document the disappearance of an old friend. When seen together these images convey the changes — both visual and physical — that affect the way we perceive and understand a single motif.

Temporal change is also reflected in the effacement and disintegration of signs. Webb whimsically records "found" images of melodramatic nonsense, mustachioed burlesque queens with a colossal voyeur, and the gentle surrealism of two olfactory organs in tender embrace (pages 36-38). His photograph of F.D.R. as "Friend" (page 39) seems to comment on the wear and tear of time on things, ideas, and life itself. The juxtaposition of this heroic, if slightly tattered, image of the late President with the Norman Rockwell-like family scene ("Freedom From Want") and the vacant building all seem to suggest the discrepancies between the political idealism of the past

and the practical realities of the present.

Webb's peopled images are characteristically gentle meditations on the place of the human figure — either isolated or in groups — within the light, shadow and geometric structure of the urban environment. In his views from the Chatham Square El Station (pages 34, 35) various figures wait silently or pass one another unnoticed, each in a private realm of thought. It has been suggested that the artistic process in our time consists of "a solitary sensibility speaking to another solitary sensibility."[72] These images portray the city as a community of strangers, while revealing Webb's own position as a solitary seer in search of symbolic human contact.

Signs from all parts of the city were of interest to Webb. In his "El Station, 53rd Street" (frontispiece), the figure of the working class woman, leaning out her window for a brief rest and breath of air, is gently contrasted with the suggestion of elegant relaxation in the "Wine and Soda — Good and Cool" advertisement. "Third Avenue" (page 42) presents a humorous conjunction between a billboard advertising "Extra Beer", a restaurant entrance, and a portly man standing beneath a sign for "Sig. Klein's Fat Men's Shop". Even the fragment of the rather bulbous car in the bottom right seems to echo this repeated motif of caloric overload and corpulence.

In "LaSalle Street at Amsterdam" (page 43) a sign on a well-stocked grocery store admonishes us not to waste food, since "500,000,000 People Are Hungry". In its combination of irony and naive humanitarianism, this message seems to echo nothing so much as a dinner-time grandmotherly truism. "Times Square" (page 45) portrays a sign painter busy at work, while other images celebrate the innocent grace of children's drawings, the stylized whimsy of circus posters, and the comedy of the incongruous (pages 40, 41, 52). In his "Internal Revenue Building" (page 53) Webb juxtaposes the IRS office with a statue of the hopeless, weeping masses.

People are sensed or seen directly in all his pictures since, for Webb, the city was the product and expression of its inhabitants. In the images which directly portray people, the city becomes a backdrop for the public display of everyday human activities. We see people working, relaxing, playing, gathering together, and contributing to the restless energy of the street (pages 43-49).

Webb's magnificent "Sixth Avenue" panel (foldout,

pages 50-51) is a brilliant summary of his interest in both signs and the vitality of the street. This print, assembled from eight carefully made negatives, measures 13 by 103 inches in size. It represents a remarkable pictorial idea that successfully combines the beauty of specific details with a panoramic desire to depict the city's amazing size and complexity. The "Sixth Avenue" panel became celebrated in the decade following its creation. It was featured in the Museum of Modern Art's "Diogenes with a Camera" exhibition in 1953, and described at some length in a cover story in *Modern Photography* the next year. In 1958 the U.S. State Department made a huge 4 by 24 foot enlargement of it for inclusion in their "This is America" exhibition at the Brussels World's Fair.

In his *Modern Photography* article Webb modestly noted that

> A study of the history of photography will show few really novel concepts. I felt rather smug at having made this panel of Sixth Avenue, but was properly deflated when looking through Beaumont Newhall's *History of Photography*

which described an eight-plate daguerreotype panorama of the Cincinnati waterfront made in 1848. Webb concluded that

> Photographers, then as now, had a sense of history. The realization that things and places change creates [the] desire to show them as we saw them.[73]

In addition to its singular aesthetic appeal, the historical significance of Webb's image becomes clear on viewing this section of Sixth Avenue (the Avenue of the Americas) today. While the block immediately to the south still contains a few structures dating from the post-war era, the remarkable storefronts and signs between 43rd and 44th Streets have completely disappeared.

Webb's Parisian photographs continue many of the themes he first explored in New York. His "Rue du Four" (page 62) reveals his sensitivity to the interrelationships between buildings, people, residences and shops, while suggesting how neighborhoods turn in on themselves, away from the major thoroughfares.

A sense of history and human presence is subtly re-

vealed in his image "Rue de la Huchette" (page 63) which depicts the street described in loving detail in Elliot Paul's book *The Last Time I Saw Paris* (1942). Paul wrote about the street's residents, shopkeepers, and bar patrons. The memories of these colorful common folk, in addition to celebrated visitors such as Gertrude Stein, Ernest Hemingway and F. Scott Fitzgerald, fill the space of Paul's literary block. His book ends with the German occupation of Paris at the beginning of World War II. As he sorrowfully prepared to leave, Paul walked his favorite street one last time and wondered, "How would these building fronts impress a man who had not been here before, a photographer, a traveler, a dweller in another quarter or country?"[74] Webb's work, in its sensitivity to details, history and the human trace, provides an eloquent response to Paul's question.

Webb reveals his continued interest in both portals and signs. In his numerous photographs of passageways he reminds us of the variety of spaces that make up the human world: interior and exterior, public and private, street and courtyard. These photographs (pages 64, 65, 67, 68, 69, 86) evoke feelings of movement, mystery and memory; they are about the intimate sensations of a public world newly discovered. In these and other images signs are perceived as informational parts of a larger whole (pages 65, 67, 85, 86), or as subjects in and of themselves (pages 66, 73). In "Shoemaker" (page 72) Webb pictures the very simplest form of sign: a display of actual products that communicates with a mute, poetic clarity. In his "Lamps of Paris" series (pages 74-77), Webb focuses on a particularly characteristic Parisian motif. These lamps are also signs, remnants of a disappearing age, and are recorded in contexts that display the evidence of time and change.

Webb's images of people capture a sense of communal energy and individual presence. From the angular march of pedestrians across a cobblestoned street (page 78) to the gentle reverie of strollers on the Montmartre steps (page 87), these photographs suggest the varieties of experience contained within the world of the great city. A lone painter works at his easel beside the Seine (page 89), a metaphoric reflection of Webb's own artistic activity. Children are at once portrayed within the context of their environment, and subtly removed from it by the solemn formality of the pose (pages 84, 85). Elderly folk en-

velop themselves in animated conversation and memories. On seeing this image (page 82) a Frenchman exclaimed to Webb, "I can tell you exactly what these people are talking about. The two men are talking about the battle of the Marne in World War One and the two women are talking about recipes." As a metaphor for life, this blend of sustenance and sacrifice may not be too far wrong.

And finally, Webb's images of statues (pages 90-93) seem to summarize his sense of contemplation, humor and the incongruous. In their subtle anthropomorphism, these busts and figures make literal the notion that, ultimately, man shapes his artifacts in his own image. What do such icons mean and what do we do with them?

This essay might seem a paradoxical attempt to suggest the density of meaning in a clear and uncomplicated body of work. Webb's work *is* simple, but it embodies the profound simplicity of intuition and a uniquely eloquent visual intelligence. The various sections of this essay have focused on biographic facts, Webb's personal writings, contemporary appraisals of his work, aspects of the artistic climate of that era and, finally, a few of the photographs themselves. By this method it may be suggested how a particular body of work arises from the interplay between an artist's unique experiences and character, and the pervasive "climate of ideas" which codifies an era's communal beliefs, aesthetic possibilities and potential meanings.

Despite the quality of his work, Webb remains something less than a household name. There are a variety of reasons for this, including the fact that he is a reticent man without a burning desire for celebrity. He and his wife have lived for many years at some distance from the major art centers of the world. Since the early 1970s, the Webbs have lived first in a small village in southern France, and then in a quiet city on the coast of Maine.

Of course, the very nature of his work plays an important part in this relative lack of recognition. Like their maker, Webb's pictures are characteristically quiet and unassuming. They are not controversial or sensational. And, unlike his friend Harry Callahan, Webb was not a formal innovator, a photographer who consciously challenged and extended the visual syntax of the medium itself.[75] Webb's photographs have consistently been about the

world, time and humanity, rather than issues of abstraction, perception and reflexivity. Thus, to a certain degree, his work has resisted some of the modernist currents of the post-war world. One aspect of the modernist sensibility has been its utopian desire to escape from, or transcend, history. By contrast, Webb's photographs are rooted in history, mortality and the physical. As an artistic statement they reveal a world that we have gradually ceased to fully recognize as our own.

Webb's images exemplify the finest mid-century American photography that was both resolutely personal and deeply concerned with realist and humanist issues. Such work may be said to be sincere in the sense that Lionel Trilling used the term in his book *Sincerity and Authenticity*.[76] For Trilling, this pair of attributes illuminates a shift in sensibility between the 18th and 20th centuries, from the artist's concern to locate himself truthfully in relation to others, to a primary need for self-knowledge and independence. This movement toward personal freedom at the expense of social cohesion may be said to lie at the root of modernist thought. Webb's work represents his attempt to balance these divergent ideals to create an authentic art that remained sincere, a personal art that celebrated the positive forces of social cohesion. This is, in short, an art of primarily realist, humanist, historical and empathetic concerns.

It had become a modernist commonplace by the 1950s to see the city as the manifestation of the profound cultural ills of fragmentation, alienation, the dissolution of communal bonds, and the loss of a unified sense of purpose. The "paved solitude"[77] of the city street came to represent not individual freedom, but existential isolation.

A primary instrument of mass society, the featureless modern city undermines all the intermediate structures — neighborhood, families, guilds, nationalities, churches — that might reinforce a man's compound grasp of his uniqueness and his community, and thus mediate between him and the social mass.[78]

At the same time, the primary artistic currents of the post-war years led away from "official" American culture. Such movement was typically a personal retreat inward, to an art of difficulty and unpopularity, or one of myth, abstraction and universals. In his own way, Webb was part of

this general movement. In his diary, he commented frequently on his status outside the highly charged, competitive society around him. Webb noted that when he and Callahan *"became interested in photography, we lost our competitive spirit and that is what makes America tick."*[79] In the 1950s his movement from the competitive center of American culture was both spatial and temporal: his residence in Europe was followed by his rediscovery of the 19th century pioneer trails.

But Webb's photographs gain their special quality, in large part, by combining the psychic reality of the urban experience's fragmentation and alienation with a more hopeful and unified vision. Webb sustains some of Whitman's century-old optimism, recording the urban experience as a human creation expressing the vitality of a great, living whole. Whitman's "urban enjoyments involve not the self's extinction...but its expansive merger with a collective life."[80] The city, for Webb as much as Whitman, means a "congregation of bodies — not an antagonistic rabble of disparate selves but a common identity."[81] In their avoidance of bitterness and despair, Webb's photographs refute Auden's belief that "the world as it appears to animals or cameras is one in which time is the enemy and human events are without significance."[82] For Webb, the eloquence and poignance of human events are revealed precisely in the traces of time. And the city's vitality is seen to stem from the heat of a multitude of individual lives, each discrete and real.

At the time these photographs were made, New York had become the world's leading city. The United Nations building was nearing completion in 1948, and there was hope that the diversity and vitality of New York itself could symbolize a new global unity. At this time, E.B. White wrote that the mixture of races and creeds in the city

make New York a perfect exhibit of the phenomenon of one world. The citizens of New York are tolerant not only from disposition but from necessity. The city has to be tolerant, otherwise it would explode in a radioactive cloud of hate and rancor and bigotry.[83]

This kind of unity, stemming from a dynamic tension of tolerance and cultural diversity, represented the dream of a war-weary world for stability and peace. For Webb, the city was a richly evocative palimpsest of past and present, the crass and the spiritual, ambitions and dreams, success and failure, rationality and absurdity. In sum, it represented the complexity of life, memory of the past, and hope for the future in a time of healing and new beginnings.

Among its other meanings, and its consistent formal beauty, Webb's photography is the record of a personal, loving investigation of the human aspects of place. Webb's places represent the richly textured fabric of human history, preserving the evidence of innumerable lives, hopes, foibles and faiths. His pictures reveal a deep appreciation for the singularities of intimate spaces while suggesting a world in which one might feel welcome anywhere. In its extended meditation on roots and transience, Webb's work centers on the simple notion of home. His photographs are about the eloquence of the commonplace, and the process of gentle understanding by which we seek to make every place a source of meaning and nourishment.

NOTES:

1. Unless otherwise specified, quotes by Webb are from interviews conducted by the author in 1984-85.

2. For background on Siegel, see John Grimes, "Arthur Siegel: A Short Critical Biography", *Exposure* (17:2), Summer, 1979, pp. 22-35.

3. Beaumont Newhall, "City Lens: Todd Webb's New York on Exhibition", *Artnews* (October 1946), p. 74.

4. Ibid., p. 74.

5. Webb diary, February 23, 1946.

6. Ibid., February 25, 1946.

7. Ibid., March 21, 1946.

8. Ibid., April 12, 1946.

9. Ibid., June 24, 1946; July 7, 1946.

10. Ibid., December 28, 1946.

11. Ibid., April 20, 1946.

12. Ibid., March 27, 1946. On May 6, 1946 Webb noted in his diary that he had been reading and enjoying Joseph Mitchell's book *McSorley's Wonderful Saloon* (1944), which includes a colorful profile on Masie.

13. For an outline of Stryker's activities in this period, see Steven W. Plattner, *Roy Stryker, U.S.A., 1943-1950* (Austin: University of Texas Press, 1983).

14. Webb diary, May 28, 1946.

15. Ibid., May 9, 1946.

16. Ibid., April 22, 1946.

Venice, 1984

17. Ibid., November 11, 1946.

18. Ibid., September 8, 1948.

19. Ibid., April 19, 1946.

20. Ibid., May 2, 1949.

21. Museum of the City of New York press release, September 24, 1946; in Webb archive, Center for Creative Photography, Tucson.

22. "City Lens", p. 47, 73.

23. Statement by Webb for "Diogenes With A Camera" (show #2) at the Museum of Modern Art, 1954; manuscript in Webb archive, Center for Creative Photography, Tucson.

24. Bram Dijkstra, *Cubism, Stieglitz and the Early Poetry of William Carlos Williams* (Princeton: Princeton University Press, 1969), p. 96.

25. Alfred T. Barson, cited in Lesley K. Baier, *Walker Evans at Fortune 1945-1965* (Wellesley: Wellesley College Museum, 1977), p. 10.

26. Webb diary, November 3, 1946.

27. Berenice Abbott, *A Guide to Better Photography* (New York: Crown Publishers, 1941), p. 166.

28. Ferdinand Reyher, "Atget", *Photo-Notes* (Fall, 1948), p. 19. For a discussion of Reyher, see John Szarkowski, "Understandings of Atget," *The Work of Atget: Volume IV, Modern Times* (New York: Museum of Modern Art, 1985).

29. Alan Trachtenberg, "The Presence of Walker Evans", *Atlantic* (242:3), September, 1978, p. 47.

30. Abbott, p. 167.

31. William Stott, *Documentary Expression and Thirties America* (New York: Oxford University Press, 1973), p. 4.

32. Ibid., p. 94.

33. For example, see photo-essays by Fenno Jacobs ("This is Italy" [April, 1948], "A Landscape of Industry's Leavings" [March, 1950]); Walker Evans' portfolios of Chicago (February, 1947), Paducah, Kentucky (August, 1947), Wall Street (March, 1948), and his selection of turn-of-the-century postcards ("Main Street Looking North from Courthouse Square" [May, 1948]); and the photographs accompanying stories such as "John L. Lewis Earns His $25,000" (March, 1947).

34. John Grierson, cited in Stott, p. 10.

35. Beaumont Newhall, *The History of Photography* (New York: The Museum of Modern Art, 1949), p. 186.

36. Warren Susman, cited in Stott, p. 8.

37. John Grierson, cited in Stott, p. 9.

38. Dijkstra, p. 75.

39. Michael G. Sundell, *Berenice Abbott: Documentary Photographs of the 1930s* (Cleveland: The New Gallery of Contemporary Art, 1980), p. 3,4.

40. Baier, p. 19.

41. See Sarah Greenough, "Alfred Stieglitz and 'The Idea Photography'", *Alfred Stieglitz: Photographs and Writings* (Washington: National Gallery of Art, 1983), pp. 25-26.

42. Reyher, p. 19.

43. Dorothy Norman, "An American Place", *American and Alfred Stieglitz* (New York: The Literary Guild, 1934), p. 140.

44. Dijkstra, p. 80.

45. Lincoln Kirstein, "Photographs of America: Walker Evans", *American Photographs* (New York: East River Press, 1975; first published 1938), p. 192.

46. Helen Levitt, *A Way of Seeing* (New York: Horizon Press, 1981); with untitled essay by James Agee, p. xii.

47. Ansel Adams, "A Personal Credo", 1944; reprinted Nathan Lyons, ed., *Photographers on Photography* (Englewood Cliffs: Prentice-Hall, 1966), p. 25.

48. Todd Webb, "Why And How This Book Came To Be"; introduction to *The Gold Rush Trail*; manuscript in Webb archive, Center for Creative Photography, Tucson.

49. *Agee*, p. xi.

50. Kirstein, p. 188.

51. Alfred Kazin, "New York: The Writer in the Powerhouse", *The New York Review of Books* (32:15), October 15, 1985, p. 26.

52. *A Way of Seeing*, p. xii.

53. Kirstein, p. 191.

54. Frederick R. Karl, *American Fictions 1940-1980* (New York: Harper and Row, 1983), p. 25.

55. Leo Braudy, "Realists, Naturalists, and Novelists of Manners", *Harvard Guide to Contemporary American Writing* (Cambridge: The Belknap Press, 1979), p. 86.

56. Ibid., p. 85.

57. Ibid., p. 86.

58. Alan Trachtenberg, "Intellectual Background", Ibid., p. 2, on Lionel Trilling's essay "The Meaning of a Literary Idea" (1949).

59. Dijkstra, p. 146.

60. Ibid., pp. 102-03.

61. Reyher, p. 16.

62. *A Way of Seeing*, p. xi.

63. James Thrall Soby, cited Baier, p. 22.

64. Harry Callahan, "An Adventure in Photography", 1946; reprinted *Photographers on Photography*, p. 40.

65. Ansel Adams, pp. 26, 29.

66. Norman, p. 141.

67. Arthur Siegel, "Fifty Years of Documentary", 1951; reprinted *Photographers on Photography*, p. 90.

68. Webb diary, December 14, 1946.

69. Monroe K. Spears, *Dionysus and the City: Modernism in Twentieth-Century Poetry* (New York: Oxford University Press, 1970), p. 88.

70. Gaston Bachelard, *The Poetics of Space*, trans. Maria Jolas (Boston: Beacon Press, 1969), p. 224.

71. James Baldwin, *Go Tell It On The Mountain* (New York: Dell Publishers, 1953), pp. 50, 49.

72. Braudy, p. 133.

73. Todd Webb, "6th Ave. Facade", *Modern Photography* (18:4), April, 1954, p. 110.

74. Elliot Paul, *The Last Time I Saw Paris* (New York: Random House, 1942), p. 399. Webb had read and enjoyed this book before making this photograph.

75. In his diary, March 6, 1947, Webb described his reaction to seeing new prints by Callahan: "Most of them were done by moving the camera and double exposures and other very tricky stuff. I just couldn't make head or tail of it and I was very sorry that I couldn't. I know Harry is driving at something and I just can't criticize what he is doing because I just don't understand it."

76. Lionel Trilling, *Sincerity and Authenticity* (Cambridge: Harvard University Press, 1971); see also Richard Sennett, *The Fall of Public Man* (New York: Vintage Books, 1974).

77. This phrase, from Hawthorne, forms a central motif of Burton Pike's *The Image of the City in Modern Literature* (Princeton: Princeton University Press, 1981).

78. James Dougherty, *The Fivesquare City: The City in the Religious Imagination* (Notre Dame: University of Notre Dame Press, 1980), p. 107.

79. Webb diary, March 29, 1946.

80. Peter Conrad, *The Art of the City: Views and Versions of New York* (New York: Oxford University Press, 1984), p. 12.

81. Ibid., p. 15.

82. Spears, p. 83, commenting on Auden's "Memorial for the City" (1949).

83. E.B. White, *Here Is New York* (New York: Harper and Brothers, 1949), pp. 42-43.